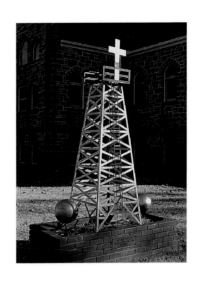

OKLAHOMA
CROSSROADS

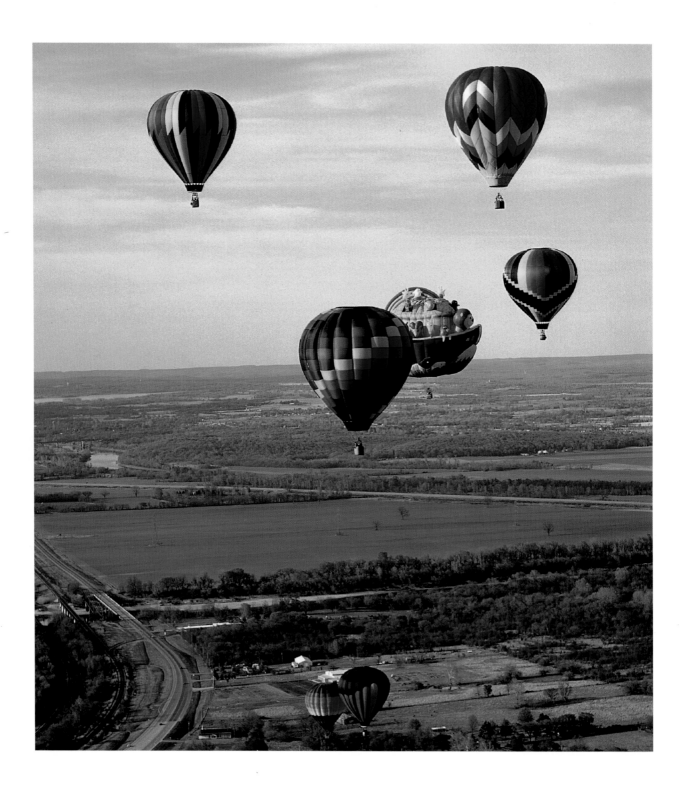

Other books by Michael Wallis

Oil Man: The Story of Frank Phillips and the Birth of Phillips Petroleum

Route 66: The Mother Road

Pretty Boy: The Life and Times of Charles Arthur Floyd

Way Down Yonder in the Indian Nation: Writings from America's Heartland

Mankiller: A Chief and Her People
(with Wilma Mankiller)

En Divina Luz: The Penitente Moradas of New Mexico

Beyond the Hills: The Journey of Waite Phillips

Songdog Diary: 66 Stories from the Road
(with Suzanne Fitzgerald Wallis)

Other books by David Fitzgerald

Oklahoma

Oklahoma II

Ozarks

Portrait of the Ozarks

Israel

Mansion Fare: The Culinary Heritage of Oklahoma Governors

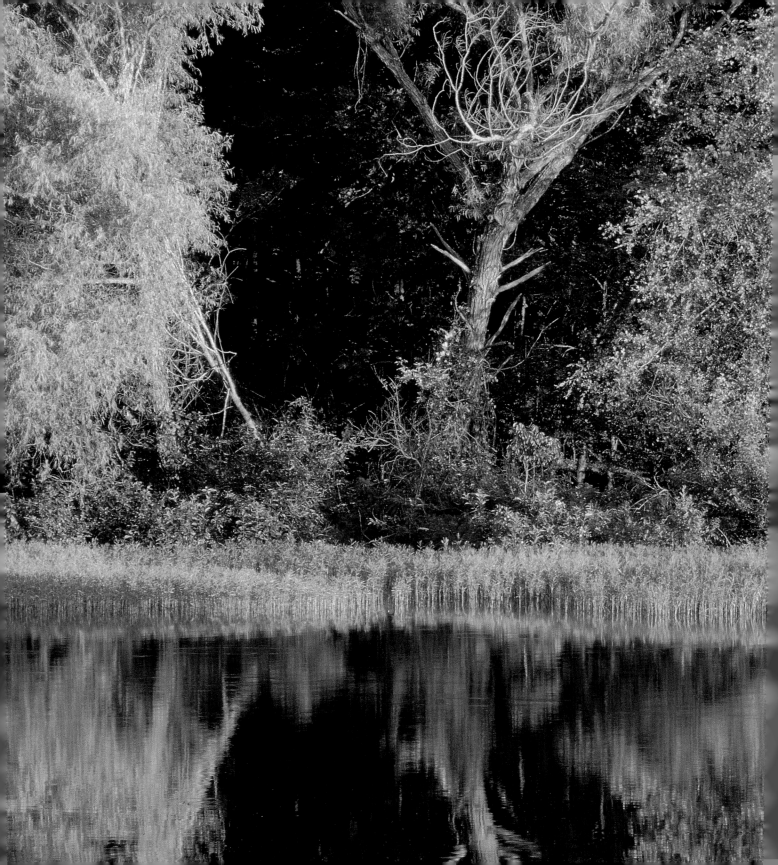

OKLAHOMA CROSSROADS

Text by
MICHAEL WALLIS

Photography by
DAVID FITZGERALD

Graphic Arts Center Publishing®

International Standard Book Number 1-55868-311-9
Photographs © MCMXCVIII by David Fitzgerald
Text © MCMXCVIII by Michael Wallis
Map artwork and compilation of photographs © MCMXCVIII
by Graphic Arts Center Publishing Company
P.O. Box 10306 ✦ Portland, Oregon 97296-0306 ✦ 503/226-2402

President ✦ Charles M. Hopkins
Editor-in-Chief ✦ Douglas A. Pfeiffer
Editors ✦ Ellen Harkins Wheat, Jean Andrews, Hazel Rowena Mills
Photo Editor ✦ Diana S. Eilers
Production Manager ✦ Richard L. Owsiany
Map Artwork ✦ Wayne Chinn
Designer ✦ Constance Bollen, CB Graphics
Book Manufacturing ✦ Lincoln & Allen Company
Printed in the United States of America

Wallis, Michael, 1945–
Oklahoma crossroads / essay by Michael Wallis ; photography by David Fitzgerald.
 p. cm.
 ISBN 1-55868-311-9
 1. Oklahoma—Description and travel. 2. Oklahoma—Pictorial works. 3. Oklahoma—Social life and cus-
toms. I. Fitzgerald, David, 1935– . II. Title.
F694.W37 1998
917.6604'53—dc21
 97-52759
 CIP

PHOTOS:

Front cover: *Eighty-four-acre Cedar Lake, seen in early morning, is surrounded by heavy pines of Ouachita National Forest.*
Half-title: *An oil-derrick memorial was dedicated by members of West Tulsa United Methodist Church in 1960 to honor former members who built the church in the teens, using earnings from refineries. In those years, the minister stood at the refinery gate with a syrup bucket to receive money.* **Page 2:** *Hot-air balloons lift off in the annual race at the Grand Moccasin Festival, a celebration of Native American culture, near Bacone College in Muskogee in mid-April.* **Pages 4–5:** *Late-afternoon light gilds Sallisaw State Park, north of Sallisaw.* **Page 7:** *The entrance of the art deco Tulsa Warehouse Market building (1930) features terra-cotta medallions.* **Page 8:** *Early morning tranquillity reigns at a marina on Greenleaf Lake.* **Page 10:** *The Fox Hotel, built in 1906 by E. L. Fox, survived gradual decline to become a treasured site in Tulsa's Brady Arts District.*

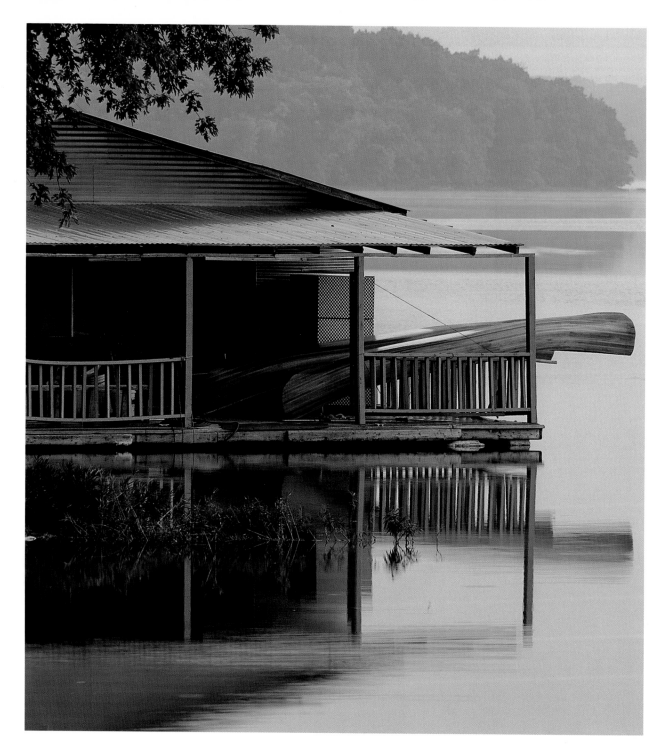

Contents

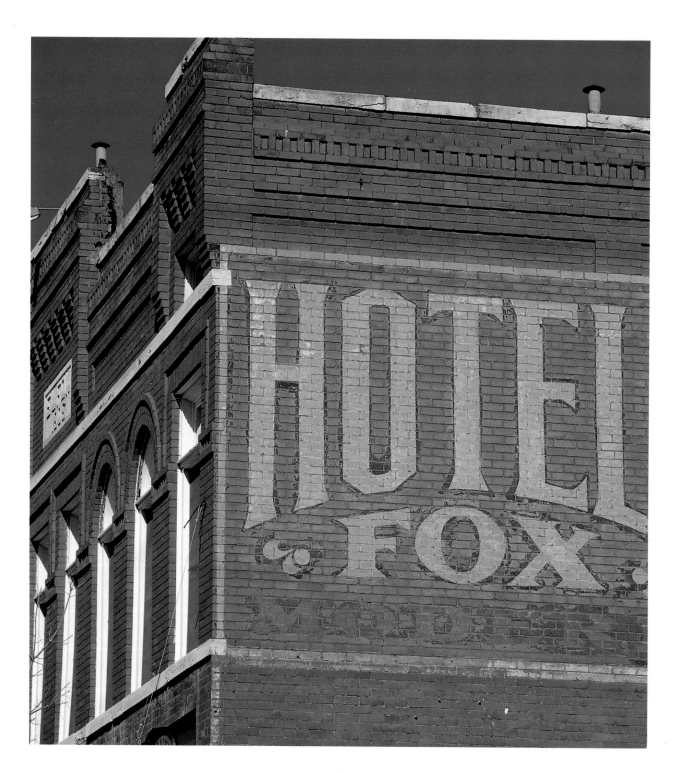

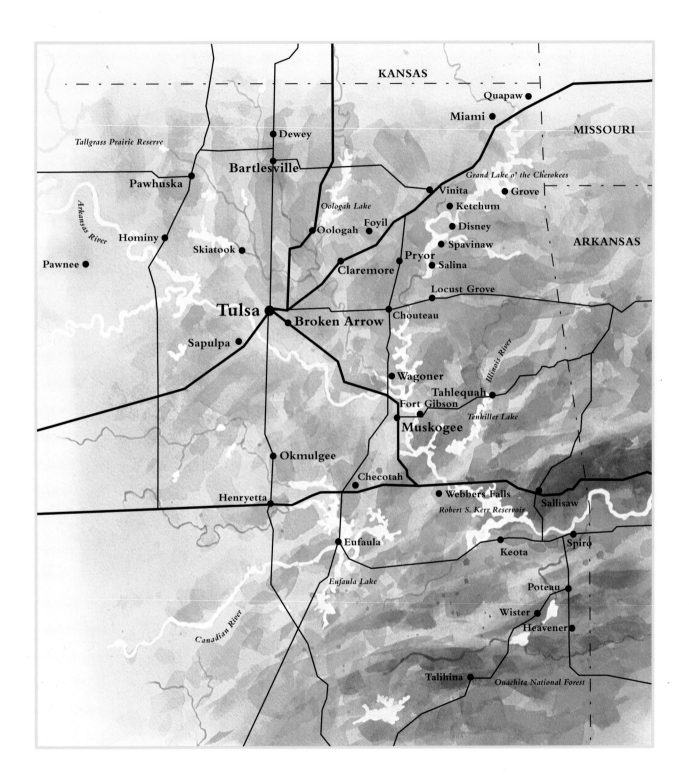

Will Rogers performed at Coleman Theatre, built by George Coleman in 1929 for the people of Miami. The building is on the National Register of Historic Places.

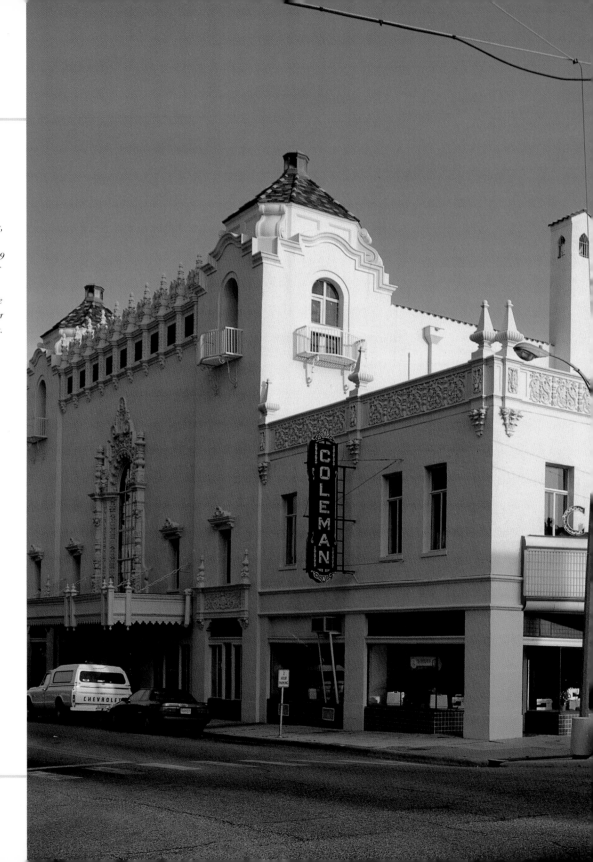

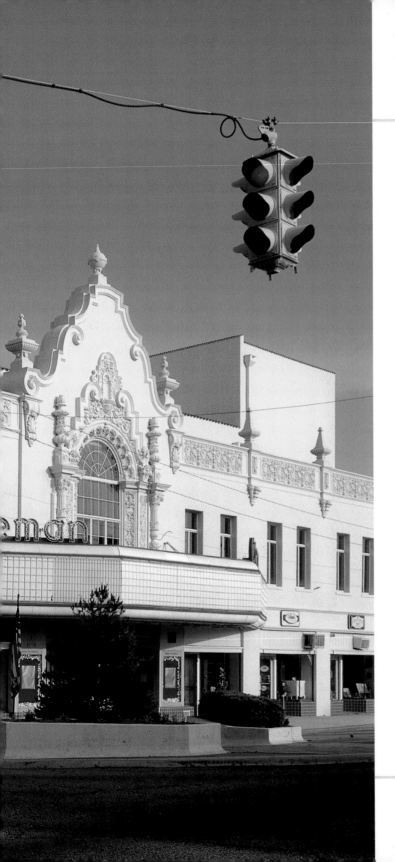

Origins

✦

Before I became a resident of northeastern Oklahoma, I never gave the place much thought. I had considered the area, and really the entire state, only as a place to pass through on my way to someplace else. It was never a destination. That changed. As I would write later, I came to northeastern Oklahoma expecting to encounter bland hamburger. Instead, I found a rich and succulent chili made of filet mignon and seasoned with plenty of spice.

In 1982, my wife and creative partner, Suzanne Fitzgerald Wallis, and I moved to Tulsa—the largest city in the region and the cultural capital of the state. It turned out to be a smart move. We never have regretted our decision. If northeastern Oklahoma is comparable to spicy chili, then Tulsa is an exquisite crème brûlée—the perfect dessert.

In the ensuing years, I have been privileged to write and publish many books. Almost every one of those works focuses directly on northeastern Oklahoma or presents an important aspect of the history, culture, and everyday life of this special place and its people.

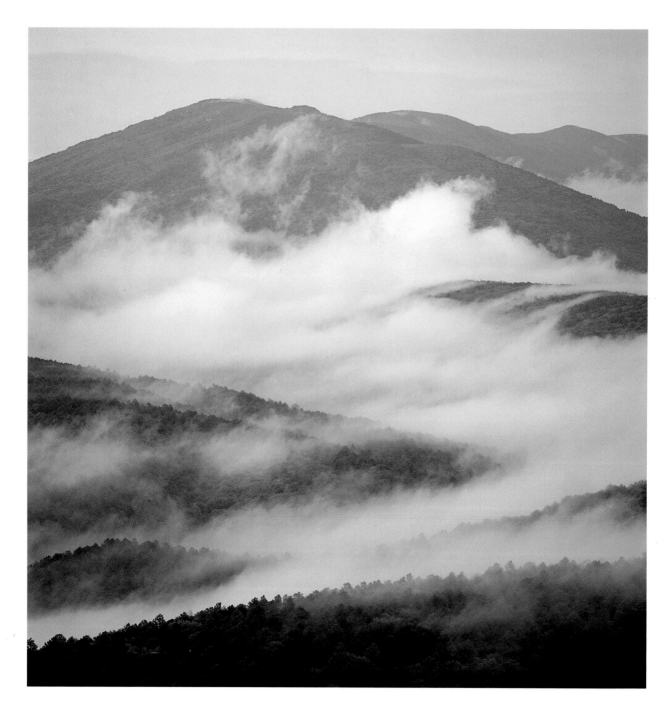

After writing books about the region's remarkable cities and small towns, its oil barons, outlaws, preachers, public servants, Native American leaders and tribes, and many articles on such important aspects of northeastern Oklahoma as the arts, weather, sports, religion, and politics, I am delighted to have this chance to produce another literary tribute to my adopted home. The opportunity is enhanced by the fact that my words are being presented in concert with the remarkable photographs of David Fitzgerald, Oklahoma's premier photographer and a true artist in every sense of the word.

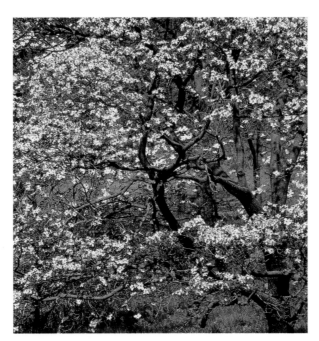

Left: Early morning rain clouds on Black Fork Mountain are visible from Talimena Scenic Drive in Ouachita National Forest.
Above: Dogwoods bloom in April at Honor Heights Park in Muskogee.

David's stunning photography, covering a broad range of subjects—from Israel to the Ozarks—caught my eye and heart long before we met and became friends. For years, both of us have served as contributors to the award-winning *Oklahoma Today*, the official magazine of the state. David's highly regarded book,

Oklahoma II, a striking portrait of the Sooner State with an accompanying essay by former Governor George Nigh, commands a place of esteem in my library.

When we finally met, I liked David instantly. I immediately thought of all the time I had spent with the master cowboy boot makers of the West, mostly talented craftsmen from Texas and Oklahoma. It is said that the very best boot makers and cobblers have "educated fingers." It struck me that a similar term should apply for photographers—the best ones have "educated eyes." If that is true, then David Fitzgerald's eyes have a Ph.D.

From the beginning of our working relationship, on a bitterly cold winter day, sitting with fortified coffees before a blazing fire, I knew we were singing out of the same hymnal, as some of our fellow Oklahomans might have put it. When David and I first conferred about this particular book with Douglas Pfeiffer, the capable editor and project helmsman at

Graphic Arts Center Publishing Company in Portland, Oregon, our creative team clicked. Our mutual desire was to create a gemstone of a book. Our primary goal was to produce photographs and text that would capture the essence of northeastern Oklahoma and the people—past and present—who are such a significant ingredient of the place.

When you have finished digesting our words and images, please favor us by making your own voyage. Explore and discover the towns and cities, the fauna and flora, the historic sites, the unusual and extraordinary of northeastern Oklahoma. Most of all, be sure to meet the people. Like us, we are confident you will find it to be time well spent. Enjoy the journey. ✦

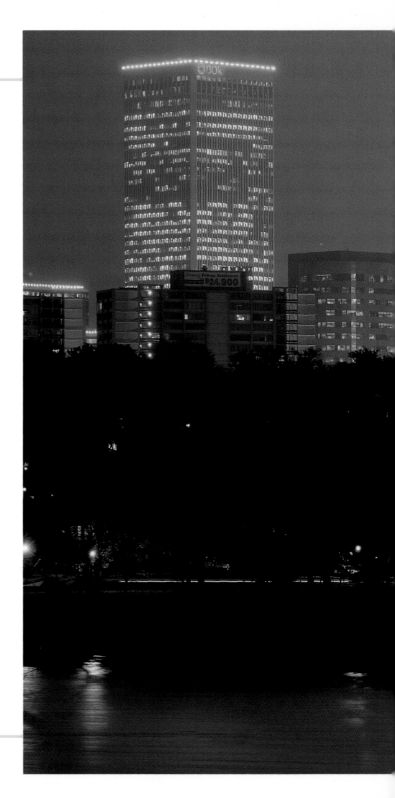

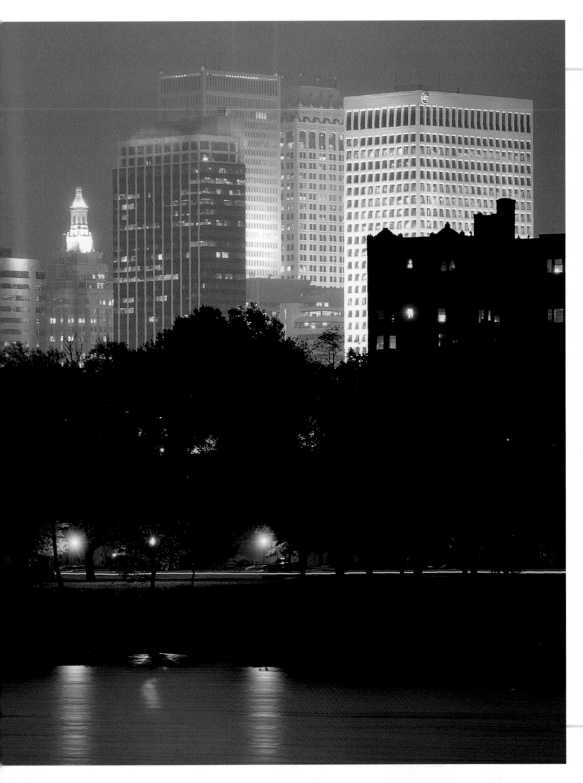

Visitors to River West Festival Park have an impressive view of downtown Tulsa, across the Arkansas River.

✦

Overleaf:
Hand-painted Indian motifs are on the ceiling beams of Will Rogers Memorial, above the famous bronze statue of Rogers by Jo Davidson. The memorial was opened in 1938.

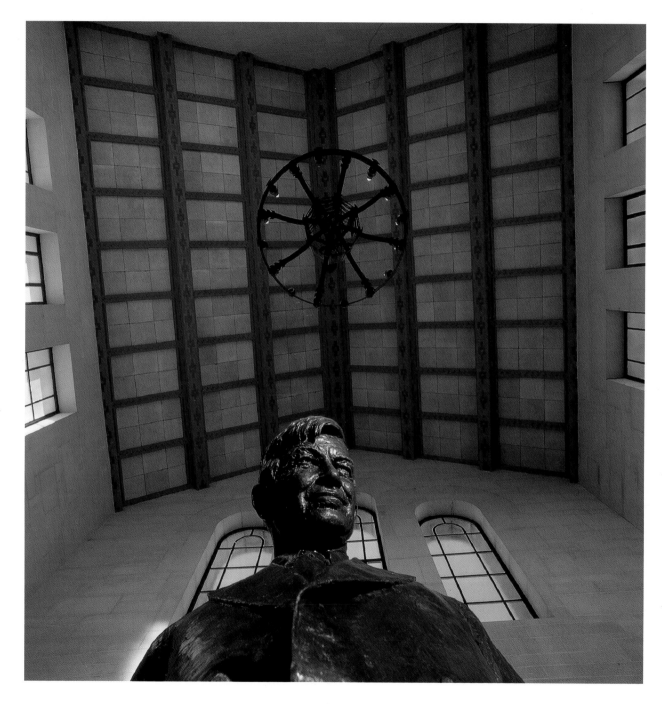

Oklahoma is tallgrass prairie and everlasting mountains.

It is secret patches of ancient earth tromped smooth and hard by generations of dancing feet.

It is the cycle of song and heroic deed. It is calloused hands.

It is the aroma of rich crude oil fused with the scent of sweat and sacred smoke.

It is the progeny of an oil-field whore wed to a deacon; the sire of a cow pony bred with a racehorse.

It is a stampede, a pie supper, a revival. It is a wildcat gusher coming in.

It is a million-dollar deal cemented with a handshake.

Oklahoma is dark rivers snaking through red, furrowed soil, lakes rimmed with stone bluffs.

It is the ghosts of proud Native Americans, crusading Socialists, ambitious cattle kings,

extravagant oil tycoons, wily bandits. It is impetuous and it is wise.

A land of opportunists, resilient pioneers, and vanquished souls,

the state is a crazy quilt of contradictions and controversies, travails and triumphs.

It has been exploited and abused, cherished and fought over.

It is a puzzling place.

Forever, Oklahoma is American through and through.

— Michael Wallis
Way Down Yonder in the Indian Nation

Late-afternoon sunlight bathes tranquil Sallisaw State Park, north of Sallisaw.

Prelude

◆

In the blazing hot summer of 1980, when I first spent a significant amount of time in Oklahoma—especially the northeast—a single journey left me with vivid impressions of the land and the people.

In Tulsa one scorching afternoon, I encountered a man who put me in mind of some of the silent men with empty eyes who occasionally appeared at the door of my boyhood home, looking to do a little work in exchange for something to eat. This fellow, sitting beneath a gnarled cottonwood on the banks of the Arkansas River, was pleased because it was twilight and he was another day closer to dying. A long time ago, he had heard that a person can wear out his heart by sleeping on the left side. He said he had slept in that position ever since. He also told me straight out that it had been years since he had liked himself—almost a lifetime ago, when he was young and strong and gave a damn.

He had been an Oklahoma cowboy and could ride, rope, and holler like a banshee. Then his life fell apart. A crippling fall from a bucking bronco at a two-bit rodeo had left him with a broken back, a

This 1926-1927 country home of oilman Frank Phillips is on the grounds of Woolaroc Wildlife Preserve and Museum near Bartlesville. Here Phillips entertained Will Rogers, Edna Ferber, and others.

◆

permanent limp, and a bad attitude. For good measure, a steady diet of ninety-proof whiskey stopped him from ever climbing into a saddle again.

The man allowed that he had lost everything. He had no more family, no more friends, and no more high-speed gallops on spirited cow ponies. He had no more self-respect. It had been years since he had looked in a mirror. He said he had become a street person—just a nice way of saying bum.

I walked a ways with the man. He pointed upstream to his home. It was a makeshift camp of cardboard boxes and Goodwill blankets beneath the old

Eleventh Street bridge. Like the man, the bridge had been abandoned, but at one time it was the way Route 66 crossed the Arkansas at Tulsa. It no longer was used for vehicular traffic, but sat neglected and forlorn next to a new and improved bridge.

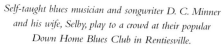

Self-taught blues musician and songwriter D. C. Minner and his wife, Selby, play to a crowd at their popular Down Home Blues Club in Rentiesville.

We stood there and neither of us spoke a word. I let my thoughts take me to the time before any bridges spanned the Arkansas. I considered the early Native Americans who came to this place and had to find the best way to cross the sometimes treacherous

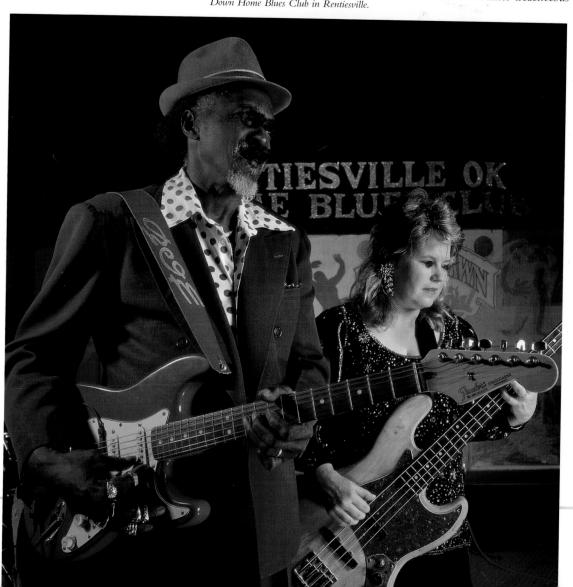

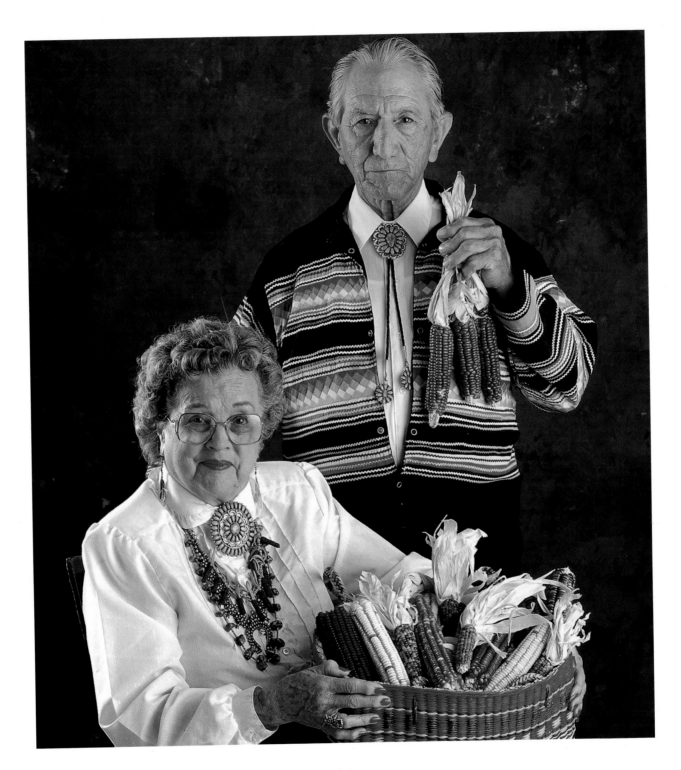

waters. I thought about the cattlemen herding hundreds of Texas longhorns across a rocky ford in the shallows of the river. I imagined the slow ferryboats loaded with passengers, and the first railroad bridge, erected back in the 1880s. Then I recalled reading about the crude toll bridge—long disappeared—that had been built in 1903. Workers and machines crossed it to get at the rich oil fields waiting on the other side, helping to assure Tulsa's future.

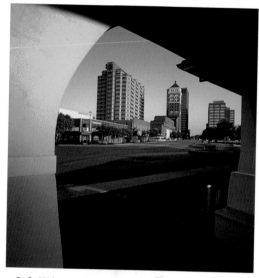

Left: Waltena and Raymond Red Corn of Pawhuska have saved their family's traditional corn from extinction.
Above: The Phillips Petroleum Company buildings in Bartlesville can be seen from the porch of the Chamber of Commerce.

of some pals to share some of their jug of vintage rotgut. Instead, he picked up his pace, not even bothering to check nearby pay telephones for forgotten coins. He told me he would go to a local mission for a supper of fried chicken and biscuits, a hot shower, and a night under cool sheets. He said all he had to do in exchange was endure a few hymns and listen to a fire-and-brimstone sermon delivered by a reformed drunk.

In the shade of an imposing bank building, the man from the river shook my hand and bade me farewell. But as he walked away, he stopped and turned. He reached into his bag and gave me his prized tomato and told me to enjoy it. He thanked me for spending time with him. Finally, he said maybe he would sleep on his back for a while and give his tired heart a rest.

After a few minutes, we moved away from the river and headed through residential neighborhoods toward the art deco towers dotting the downtown skyline. The old rodeo rider clutched his bag of worldly possessions—a broken pocket comb, some raggedy underwear and socks, a sack of tobacco and rolling papers he called "cowboy bibles," and a tarnished belt buckle the size of a saucer which he had won long before at a rodeo. There was also a good-sized tomato wrapped in newspaper in the bag. He admitted to me that it had been liberated from a backyard garden the night before.

As we walked and swapped stories, a morsel of survivor cried out from the man. He ignored the pleas

When he left, I bit into the tomato. It was vine ripened and juicy and tasted of summer. The juice ran down my chin and droplets splattered on the red-hot sidewalk. When I looked up, I saw that the man was gone—lost in the pedestrian traffic of a city that did not even know he existed.

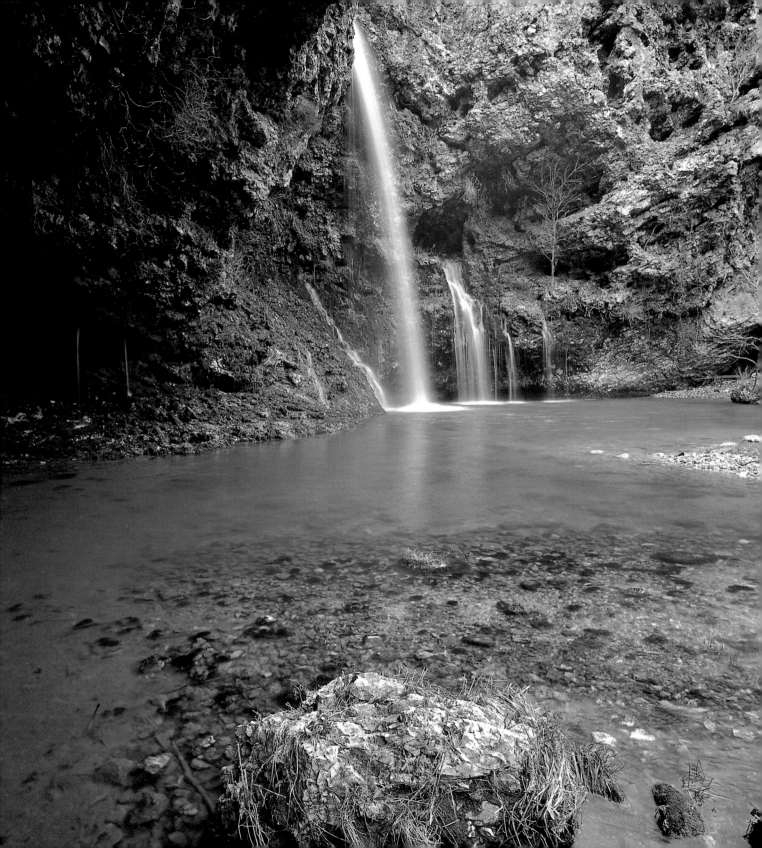

The memory of that old rodeo cowboy I met so long ago stays with me. I still find it slightly ironic that in this mineral-rich land that has produced so many oil millionaires, one of my dominant early recollections is of a salt-of-the-earth soul who was in my life for such a fleeting time and whose name I never knew.

Several years after my brief encounter with the old rodeo cowboy, I met Sam Walton, another son of Oklahoma, cut from the same homespun cloth of the heartland. I keep many sweet memories of my time spent with this classic entrepreneur who had become the largest retailer in the world, yet managed to retain the common touch.

I tagged along with "Mister Sam" on a south Texas quail hunt, accompanied him to meetings with other corporate giants and heads of state, and sat with him and his family at a fancy Waldorf-Astoria ball when he was selected CEO of the decade. Yet my fondest remembrance is of the day the two of us—just Sam and I—took off in his small airplane and made the rounds of part of his Wal-Mart empire.

We ended up visiting stores in seven states that day, but the best part of that remarkable journey was the beginning, when Sam guided his Cessna beneath dark clouds hovering over northeastern Oklahoma. As the plane glided over Jay, Salina, Pryor, and Claremore—the hometown of Walton's wife, Helen—Sam and I discussed whether his Wal-Marts were really good for my beloved Route 66. The tremendous Wal-Mart impact on small-town America was an ongoing debate between us. It always ended in a draw, with each of us admitting that the other had made some valid points.

While we were still high above northeastern Oklahoma, our conversation turned to other matters, especially the strikingly

Left: Natural Falls State Park on scenic U.S. 412 has the highest waterfall in Oklahoma—more than seventy-seven feet.
Below: This house stands in Adams Corner, a re-created nineteenth-century Cherokee town near Park Hill. The bed seen through the door was brought over the Cherokee Trail of Tears.

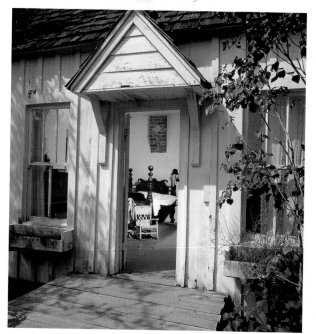

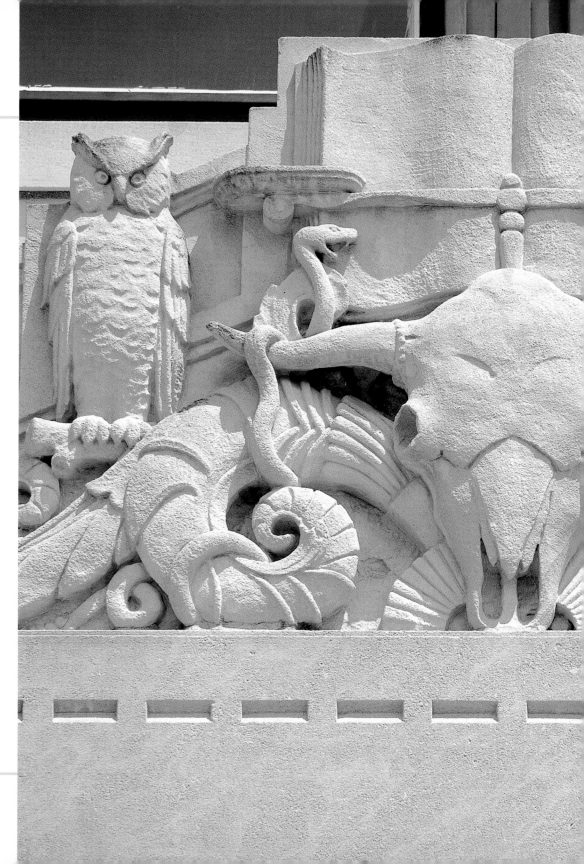

A detail of the frieze above the south entrance of the Pawnee County Courthouse reflects the state's Indian heritage and the blending of cultures that created Oklahoma. The courthouse was built in 1932 by Smith and Senter.

Overleaf ➤:
Sunrise is viewed from Emerald Vista on Winding Stair Mountain in Ouachita National Forest.

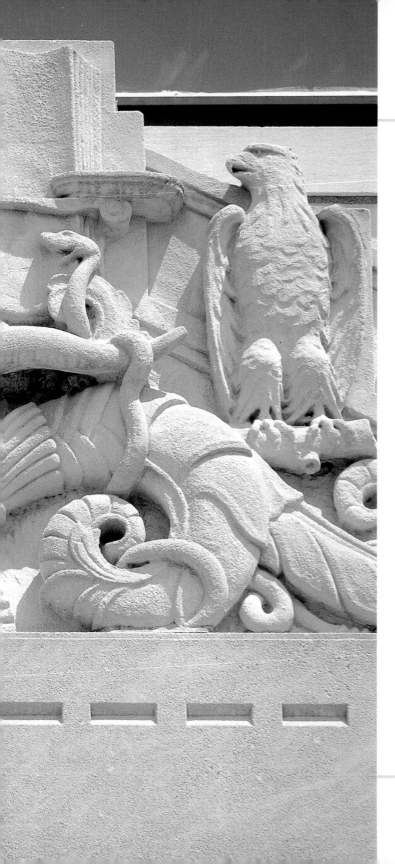

lush countryside passing in review below us. A parade of spring rainstorms had brought back to life every bush, tree, and vine. Dogwood blooms floated in the air. Farm ponds, creeks snaking through pastures and woodlands, and large lakes glistened in the morning sun.

On a northerly path toward Kansas, Sam and I looked for familiar landmarks. We spied Will Rogers' old family home, perched high above Oologah Lake, and the skyline of Bartlesville. We saw the Nowata County town of Lenapah, a name adapted from the Delaware tribe's name for itself, which means "real or genuine men." We ate Moon Pies, sipped lukewarm thermos coffee, and talked about how much the land must have changed since human beings first came on the scene—back before a patchwork of pastures and towns and reservoirs created by men dotted the land, back before Route 66 and Wal-Marts existed. I will remember that flight forever.

In the time between my encounters with the "tomato man" and with Sam Walton, I came to know an extraordinary woman.

I met Wilma Mankiller, the first woman to lead a major Native American tribe, just before she became principal chief of the Cherokee Nation of Oklahoma, in 1985. At Mankiller Flats, her home on 160 acres of ancestral property in eastern Oklahoma, we shared stories and ideas. From the beginning, we felt as though we had known each other forever.

Wilma's quiet strength, dignity, and resolve, along with an abiding sense of her Native American

heritage, have helped shape this remarkable leader. During her ten years as chief and in her continuing work for human rights, she and her husband, Charlie Soap, have been as comfortable with power brokers and world leaders as with their neighbors and friends in rural Oklahoma. Wilma and Charlie are true children of the 1960s, and they epitomize the best of the Indian Territory legacy that still can be found on the prairies, in the cities and small towns, and throughout the woodlands of Oklahoma.

I have walked with Wilma through the rolling hills of her property, and we have sat together on her front porch, listening to cardinals and mockingbirds. I always have been attracted to her deep love of the land and of nature.

But my most vivid memory is of a September Sabbath when we traveled with family and friends to an old Cherokee dance ground where native people from different tribes had gathered to celebrate. Throughout the night, we danced around the sacred flames and sat and talked beneath a clan arbor. We could hear the haunting chants and music of the night. It was potent and divine.

I thank my lucky stars for my time with Wilma Mankiller, with Sam Walton, and with the tramp I met on the Arkansas River who gave me a tomato, and with all the others—Oklahoma men and women of all descriptions. Some of them hailed from pure Okie stock, others were high-octane blue bloods, and a few were a combination of both. All of them—no matter their station in life—are memorable. They have left me a great deal richer for having crossed their paths.

I have met them everywhere I journeyed in Oklahoma's northeast—on the back roads, the busy superhighways, the dirt and gravel ranch and farm roads, the city streets, the many rivers and streams and

Trees shade the west entrance of "the White House on the Verdigris." Will Rogers was born there on November 4, 1879. His parents, Mary America Schrimsher and Clement Vann Rogers, were prominent mixed-blood Cherokees.

historic watery pathways, and along all the other trails, both old and new and some forgotten, that crisscross the countryside.

They waited for me at oil tycoon Frank Phillips' ranch-retreat called Woolaroc, and in Tulsa at Cain's Ballroom, the Brady Theater, the Creek Council Oak, and the city's world-class art museums. I encountered them at the final resting place of cowboy philosopher Will Rogers in Claremore; at Slick's, a Muskogee institution famous for its succulent barbecue; and on the edge of Pawnee at Wild West entrepreneur Gordon W. "Pawnee Bill" Lillie's comfortable old home on a hilltop known as Blue Hawk Peak.

After living in this state, I came to learn that Oklahomans are the offspring of a rich variety of people who arrived on a maze of crossroads. I also learned much more.

I now understand that throughout the nineteenth century, migrant trails and commercial frontier pathways slashed across eastern Oklahoma, such as the Texas Road, the Butterfield Overland Mail Route, the California Road, and the Shawnee Trail. These busy routes transected Indian Territory, a region assigned by the federal government to Indian tribes for their own use. It was populated largely by tribes organized into "Indian Nations," supposedly protected by treaties with the United States.

By the turn of the century, after the region had been the scene of tribal battles and bloody Civil War engagements, the federal government opened the lands to white settlers. A seemingly endless wave of people of all nationalities and ethnic backgrounds poured into the territory from surrounding states. Primarily a mixed bag of southerners and midwesterners with Scotch-Irish and English ancestry, they came to Oklahoma in the series of now-famous land runs, lotteries, and sales.

A short time later, the oil industry took hold in Indian Territory, bringing even more folks from New York, Ohio, West Virginia, Illinois, Pennsylvania, Indiana, and elsewhere. From statehood, in 1907, until the present day, still others from a diversity

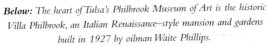

Below: The heart of Tulsa's Philbrook Museum of Art is the historic Villa Philbrook, an Italian Renaissance–style mansion and gardens built in 1927 by oilman Waite Phillips.
Right: The Tulsa skyline, with the art deco Warehouse Market building at left, shows a diversity of architectural styles.

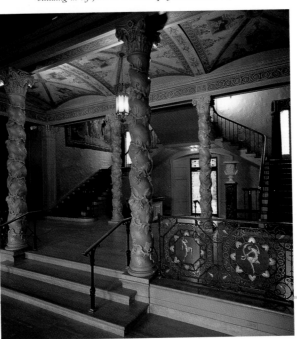

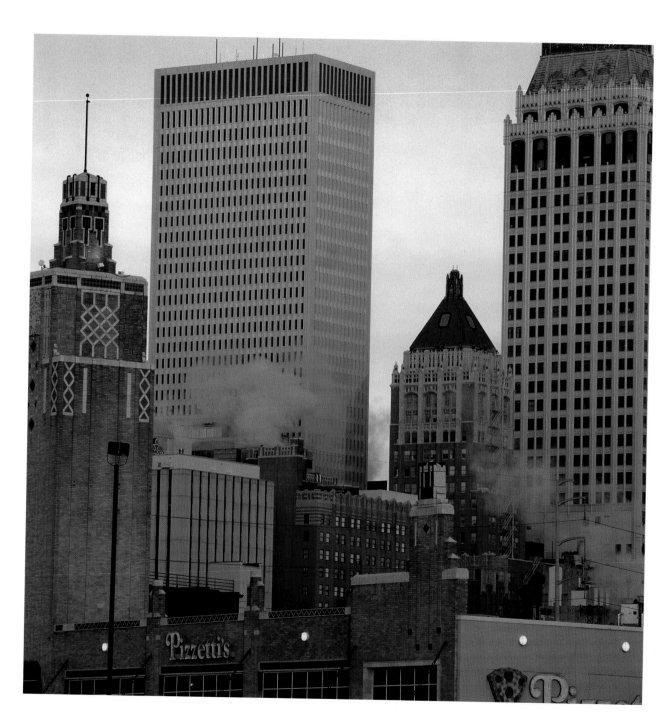

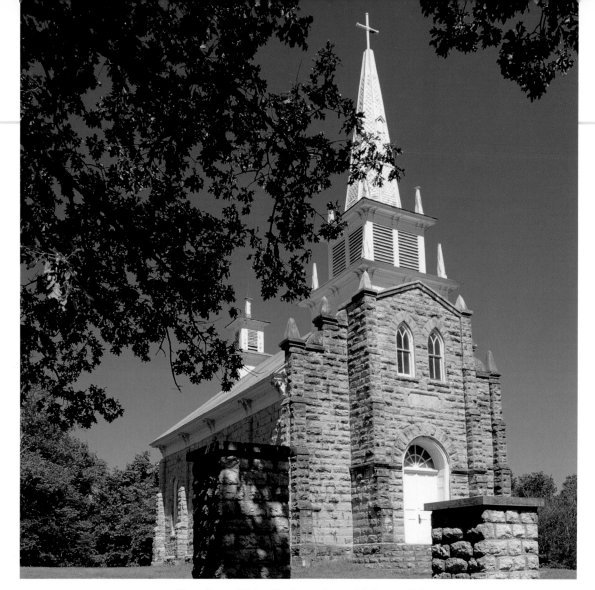

Above: Cayuga Mission Church, near Grove, originally was called Splitlog Church. Built by Mathias Splitlog, it was formally dedicated a few weeks before his death on January 2, 1897.
Right: The former Cherokee capitol, completed in 1870, is on Capitol Square in Tahlequah.

◆

of backgrounds—some God-fearing, some lawless, and some a combination of both—have adopted the region and made themselves at home. A mélange of groups and individuals—every man, woman, and child, the numer-ous tribes and clans, and the various cultural, ethnic, and racial mixes—has con-tributed. All of them have left their own particular fingerprints, stains, and marks on the fabric of Oklahoma's northeast. ◆

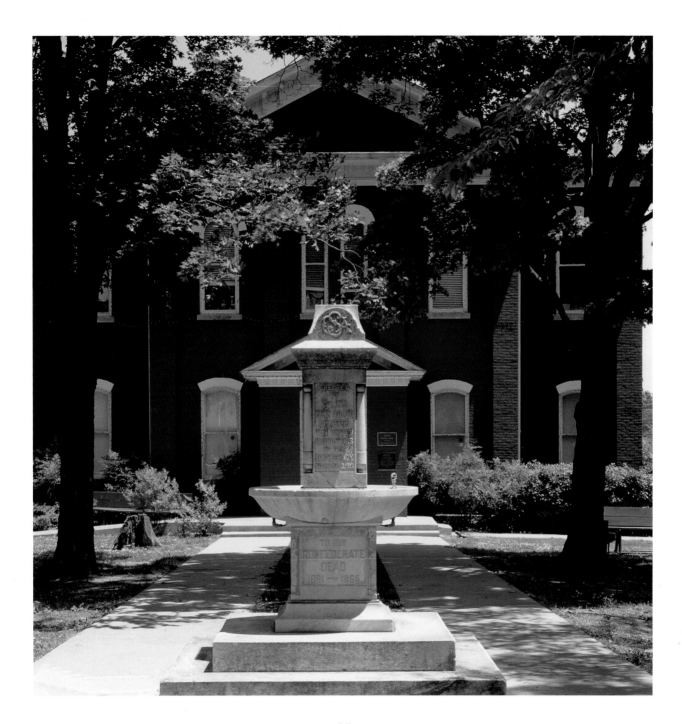

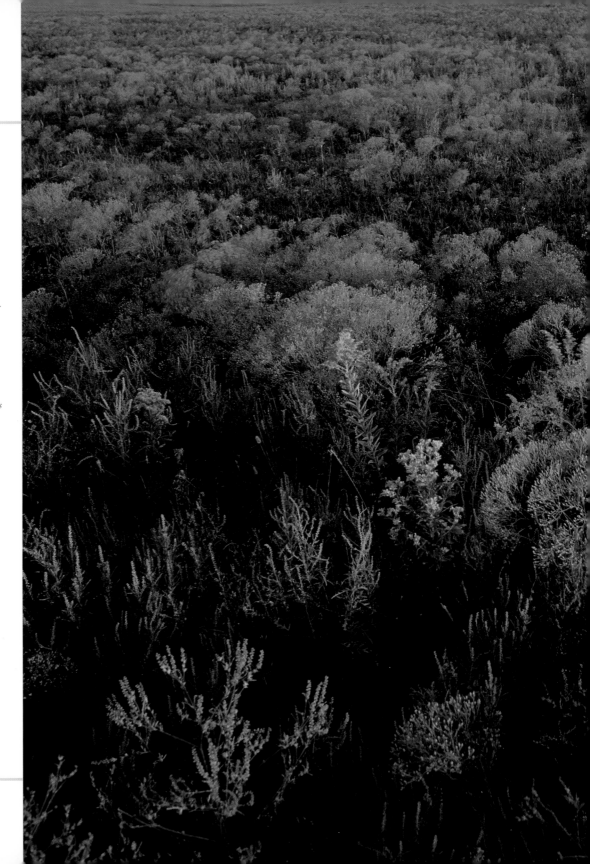

The Nature
Conservancy's
thirty-seven-
thousand-acre
Tallgrass Prairie
Preserve begins
seventeen miles
north of Pawhuska.

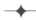

Overleaf ➤:
*The sculpted figures
above the south
entrance of Tulsa's
Boston Avenue
United Methodist
Church depict
Methodist figures
such as circuit
riders; Francis
Asbury, "the
unknown rider";
and William
McKendree.*

Passages

<p style="text-align:center">✦</p>

It is high summer in the sprawling Osage country of northeastern Oklahoma. Many miles removed from humanity and machines, the vast ocean of land, teeming with life in limitless forms, is never silent. An eternal Oklahoma wind furnishes a constant chorus of voices as it bullies and buffets the great mounds of clouds congregating high above the unbroken roll of hills and prairies.

These imposing clouds are capable of occasionally losing their temper during the sweltering dog days of summer. Then the clouds reveal their dark side. They become bloated and turn purple with rage, unleashing a barrage of short-lived but powerful storms punctuated by salvos of thunder and bursts of brilliant lightning that slice through the warm, moist air.

An important component of the drama that has been played out in these parts since long before time was invented, the natural symphony of the land may vary from the roar and bluster of furious thunderstorms to the tender caress of a soft evening breeze, more subtle than the breath of a sleeping infant. Utter stillness never has been an option in these parts.

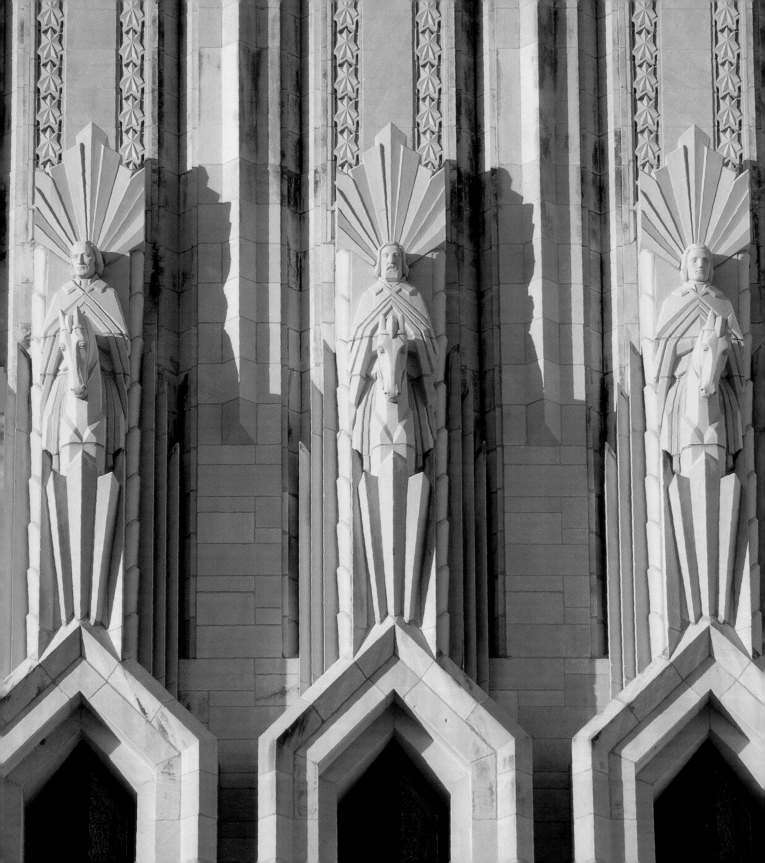

"The impression was one of space; whispering space. . . . It was wild space but never silent. In summer the grasses whispered and laughed and sang, changing to mournful whispers during the autumn, then screaming like a demented woman when winter turned the emerald to copper," acclaimed Osage novelist John Joseph Mathews wrote long ago about his prairie homeland. That poignant description from the opening chapter of Mathews' *Wah' Kon-Tah: The Osage and the White Man's Road* still fits.

But to appreciate the language and melodies of earth and sky and truly to comprehend the kingdom of northeastern Oklahoma, a person must go directly to the land. Writers, poets, musicians, photographers, and other artists and teachers can make the journey more meaningful, but it will require a personal tour of the entire region to achieve true understanding.

There is no better starting point for this trek than Osage County—the immense and often mysterious

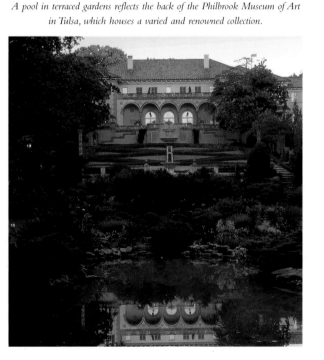

A pool in terraced gardens reflects the back of the Philbrook Museum of Art in Tulsa, which houses a varied and renowned collection.

Osage—largest of the state's seventy-seven counties, bounded by Kansas to the north. It remains one of the natural cornerstones of Oklahoma's northeast.

Travelers who wish to understand this land fuel themselves for the experience. They sip mugs of stout coffee and devour Osage Monsters—one-pound grilled cheeseburgers smothered in chili, and one of the mainstays at Teresa's, a popular cafe in the small Osage County community of Wynona. Chock-full of chopped cow and caffeine, visitors are ready to face the world and venture into the nearby hills, grasslands, and stunted forests of blackjack and post oak.

Beyond the county seat, Pawhuska, waits a sea of big and little bluestem, Indian grasses, and switchgrasses, the signature flora of the tallgrass prairie. Thousands of acres of open prairie—of what was once millions—have been saved by the Nature Conservancy. In the Tallgrass Prairie Preserve, where wildlife and wildflowers abound, visitors at least can get an inkling of

what the land must have been like before the human species arrived. Within the remnants of the once vast grassland that covered four hundred thousand square miles from Texas to Canada before farms, ranches, towns, and roads took nearly all of it, the visitor finds hints of an old footpath. The trail is flanked by faded black-eyed Susans, stands of bright yellow broom-weed, and a hodgepodge of blackberry, goldenrod, clover, thistle, and other native vegetation.

Patches of poison ivy and armies of bloodthirsty ticks and chiggers, snug among the weeds and grasses, remind human visitors to stay on the beaten path. Those who venture off the trail into the meadows and fields before the killing frosts of late autumn cause the pesky critters to retreat do so at their own risk.

Eventually, the winding path leads to the steep banks and limestone ledges of Sand Creek. One of the perennial streams of the northeastern Oklahoma prairie and home for several species of fish and turtles, the creek offers water and food for many other creatures. Both sides of the stream support a gallery forest of mainly oak, elm, ash, and hackberry. Lush undergrowth shrubs include the dogwood, which bears masses of rosy pink and creamy white blossoms in early spring, and the redbud, or Judas tree, the state tree of Oklahoma and another early bloomer.

Some of the larger bur oaks in the bottomlands reach a height of sixty feet. They yield huge acorns set deeply in fringed cups, the preferred fare of white-tailed deer, squirrels, and flocks of wily turkeys. High-climbing Virginia creeper and wild grapevines shinny up tree trunks and drape decaying logs. An assortment

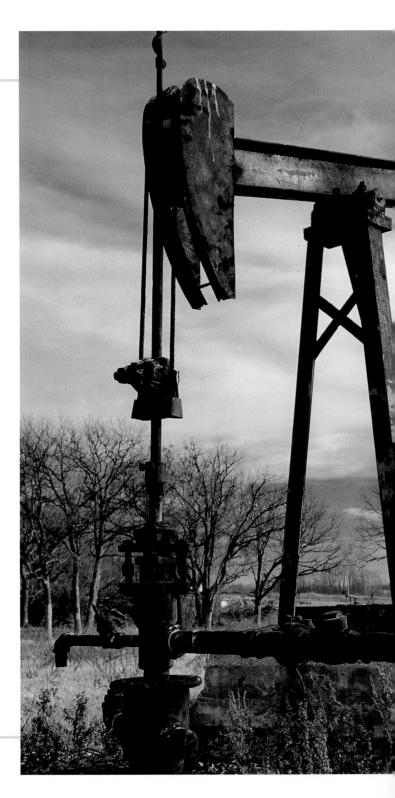

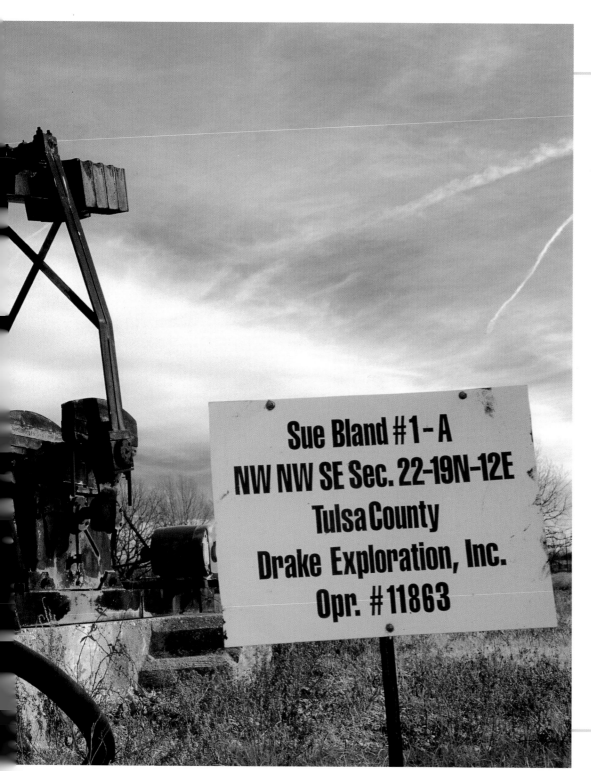

Sue Bland #1-A
NW NW SE Sec. 22-19N-12E
Tulsa County
Drake Exploration, Inc.
Opr. #11863

The Sue Bland No. 1, the first oil well in Tulsa County, was named for a Creek woman whose husband helped finance the well in 1901. The pumper jack is a replica near the site of the original, now destroyed.

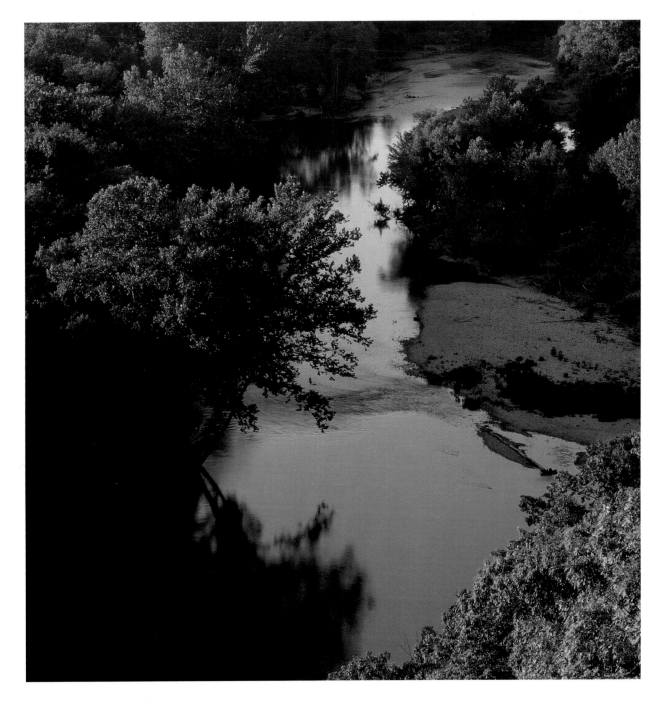

of sparrows, woodpeckers, jays, cardinals, and songbirds finds refuge in the forest corridor and keeps a lookout for hawks or other winged predators on the prowl for dinner.

Farther up the trail, near a large stand of buffalo grass, visitors notice shallow basins in the earth—buffalo wallows, created when the big shaggy beasts with curved horns rolled in the mud or dust to thwart insects and rub off part of their thick winter coats. The depressions in the prairie sod still serve other creatures. Frogs, toads, and salamanders emerge in early spring and use the old wallows as nurseries for their spawn. A chorus of springtime amphibian voices echoing from the rushes and sedges in the wallows at twilight predicts the coming rains.

Formed in the distant past, the wallows also remain as tangible evidence of the vast bison herds which were slaughtered and eventually eliminated from all the prairie lands with the coming of white intruders. Great droves of those true monarchs of the plains once roamed this land, grazing on the succulent grasses which flourished in the dark soil—shallow but organically rich—covering ancient layers of sandstone, limestone, and shale.

The bison became the basis and backbone of the entire Plains Indian culture. The Plains tribes used virtually every part of the animal to maintain their lifestyle—food, shelter, clothing, and ceremonial objects all came from the buffalo. When the bison herds diminished, the Indian lifestyle changed forever.

Before their passing, the bison were as much a part of the cycle of life in the prairie lands as the rains and fires of spring that renewed the earth. The herds helped to maintain the delicate balance of the ecosystem. Fires ignited by lightning cleaned out dead vegetation, released nutrients into the soil, and prevented alien trees and shrubs from invading the prairie. Lured by new growth, bison grazed on the lush grasses—mostly deep-rooted species that easily could survive repeated conflagrations. This helped to restore and protect the prairie by reducing fuel loads and creating natural firebreaks.

From this vista on high ground, visitors can look to the west across the vastness of eight-foot-high grasses where prairie chickens, quail, and meadowlarks find cover. In the spring, the wide variety of prairie soils will make this place a haven for Queen Anne's lace, purple windflower, snow-on-the-mountain, blazing star, and other flowers.

Although the overall scale of the tallgrass prairie has been diminished greatly, the view still touches the imagination and inspires absolute awe. Just for a moment, it is possible to imagine what the original prairie must have been like long ago—before the coming of human beings, beef cattle, barbed-wire fences, and steel plows. Visitors also can understand what the revered poet Walt Whitman meant when he wrote about his certainty that "the Prairies and Plains last longer, fill the aesthetic sense fuller, precede all the rest, and make North America's characteristic landscape."

The tallgrass prairie of the Osage—an invaluable link to nature's past—is but one of the major ingredients in

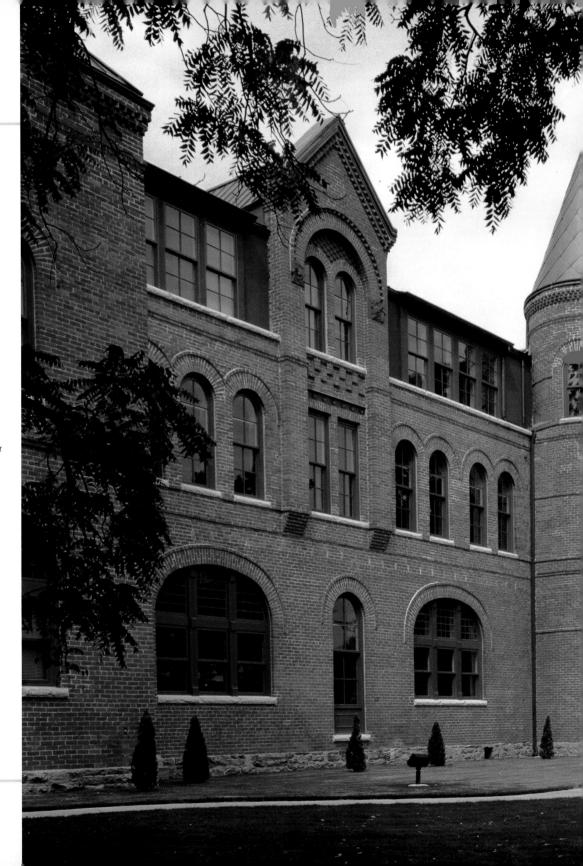

Constructed in 1887-1889 to replace the original Cherokee Female Seminary, which was destroyed by fire in 1887, this building is the centerpiece of Northeastern State University in Tahlequah.

Overleaf ➤:
Heavener Runestone State Park, two miles east of Heavener, shows fall colors through the spray of several waterfalls.

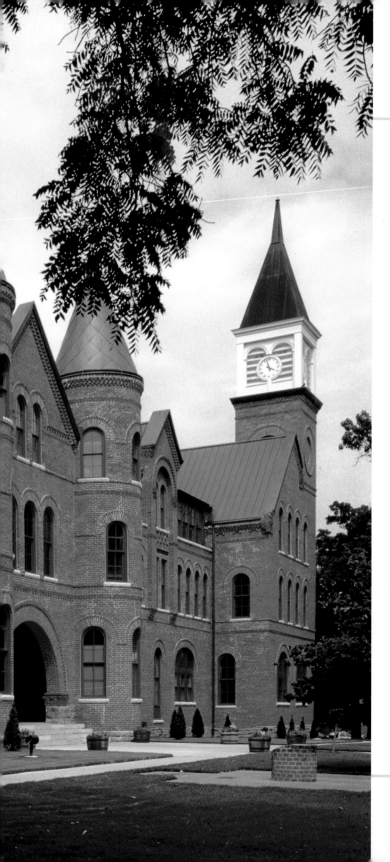

northeastern Oklahoma's environmental mix. To comprehend the whole of the region and truly learn the lay of the land—all the land of Oklahoma's northeast—travelers must visit other natural backdrops.

◆

Footloose ghosts abound throughout northeastern Oklahoma. They are at large all across the land, stalking the dimensions of the grass prairies and the deep, narrow valleys. They find cover among thickets of sumac, bois d'arc, sassafras, and persimmon, and they mingle in the timeless forests of cedar, walnut, honey locust, and sycamore.

Ghosts roost along the banks of the contrary Arkansas, the sluggish Verdigris, the scenic Illinois, the Poteau, and a slew of tributary streams and creeks. Some ghosts perch on sharp bluffs or on lakeshores of Tenkiller, Oologah, Spavinaw, Eufaula, Skiatook, Eucha, and Keystone. Others scout the everlasting Osage Hills, studded with stubborn blackjack oaks, and travel the length of scenic Talimena Trail in the Ouachita Mountains. Phantoms peek from the shadows of deserted oil rigs and derelict buildings. Restless spirits rattle in the winter wind.

Countless specters from long ago and others from only yesterday patrol the boulevards and alleys of Tulsa, Muskogee, Tahlequah, Bartlesville, and Miami, and frequent the parks, museums, and churches of those cities. They sleep in orchestra pits, at the tops of towering catalpa trees, in clumps of fiery azaleas and, like purring cats, on windowsills of

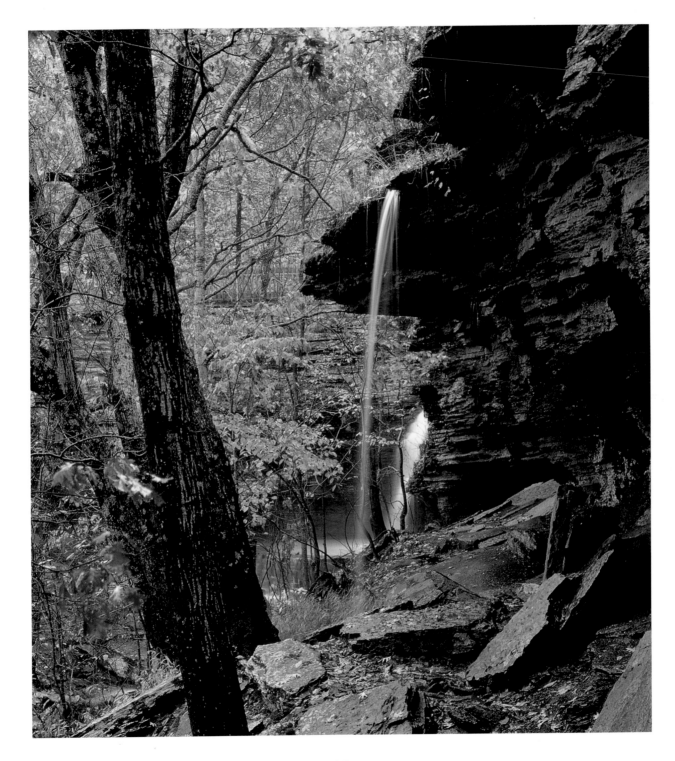

homes built before there was an Oklahoma. They congregate in small-town cafes, courthouse squares, and school yards at Okmulgee, Sapulpa, Poteau, Sallisaw, Heavener, Checotah, Pawnee, and scores of burgs no bigger than a minute.

Timeless sentinels —serene as a Sunday-morning benediction —visit oil-patch hamlets, farms and ranches, pecan groves, melon patches, and stockyards. They straddle rodeo fences, hang out at beer joints, kibitz over backgammon boards, hover in the upper reaches of corporate palaces and, like most self-respecting ghosts, gather with their pals in country graveyards.

Mostly, they go unnoticed and unheard, mistaken for the shifting evening shade, a coyote's distant song, the twilight serenade of a mockingbird, a summer breeze caressing an ocean of big bluestem. They are confused for shooting stars that streak the night heavens or for renegade tornadoes spawned by humid air flowing up from the Gulf of Mexico, colliding on the prairies with the cold winds of spring sweeping down from the north. Sometimes these spirits pass themselves off as ballerinas, museum curators, barbers, evangelists, barbecue cooks, stompdance drummers, rodeo cowgirls, bootleggers, roustabouts, and poets.

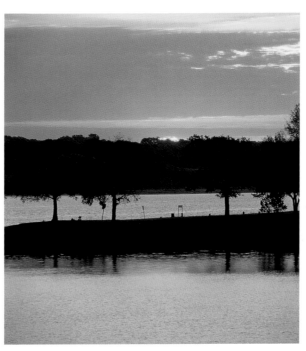

The 1,070-acre Heyburn Lake near Sapulpa offers camping, swimming, and fishing for catfish and largemouth bass.

It is only fitting that the distinct countryside and communities of northeastern Oklahoma provide sanctuary to so many ghosts. This great expanse of land always has been part of the restlessness that pushed people across North America in persistent quest of richer soils, better opportunities, and a new beginning.

If the broad western plains and golden wheatfields— where winds are born—act as the lusty lungs of the state, then the vibrant heart of Oklahoma lies in the northeast. Old Indian Territory, where so many traces, trails, paths, and highways converge, becomes the crossroads of the nation.

Northeastern Oklahoma is quintessentially American but, along with the rest of the state, it has a distinct historical development. Oklahoma is the only state that did not follow the chronological progression from "unsettled" area to territory to statehood. Its chronology became disrupted in the 1820s when the federal government designated it as Indian Territory, a holding pen for Native American tribes uprooted by the government from their homelands.

Indian Territory comprised most of the state of present Oklahoma until 1889, when the central and western areas began to be opened to white settlement. The first land run came in 1889 and the establishment of Oklahoma Territory government in 1890. Only the Five Tribes—Cherokee, Creek, Choctaw, Chickasaw, and Seminole—and a few smaller Indian Nations retained their lands in Indian Territory for seventeen more years. Finally, in 1907, decades later than surrounding states, Indian Territory and Oklahoma Territory joined the union as a single state.

The huge hunk of real estate that makes up northeastern Oklahoma remains a patchwork quilt of contradictions and controversies. It is also a locale— perhaps more so than any other part of Oklahoma— that constantly falls victim to stereotyping and is prone to cliché.

Northeastern Oklahoma, just like the rest of the state and the nation, never has been in a position to hold itself out as an idyllic utopian paradise. It always has been replete with natural challenges and all variety of flaws of

Right: Late-evening light gilds Lake Tenkiller.

the human condition. Still, many of the negative images which some people accept as accurate characterizations of northeastern Oklahoma are based on misconceptions, wholesale generalizations, and blatant twisting of the truth.

The people of northeastern Oklahoma can be their own worst enemies. Sometimes they are the ones who are most guilty of distorting their homeland's true image. They do it by rewriting or reinventing their own invaluable history or, even worse, by ignoring the past and conveniently removing from their consciousness all critical events, catastrophes, and controversies that cause them even the slightest discomfort or embarrassment.

Unfortunately, this attitude only has fostered a second-class-citizen mentality and has allowed a kind of regional inferiority complex to develop, as it also has throughout Oklahoma. The truth is, there were both bitter and sweet episodes, high and low points in the evolution of northeastern Oklahoma and the rest of the state.

On the negative side, the region was a dumping ground for entire nations of tribal people forcibly removed from their homes in the southeastern United States to Indian Territory along several infamous "Trails of Tears." Swarms of outlaws, killers, and characters of ill repute also found refuge in the Indian Nations during the colorful territorial period. Later, they were joined by wave after wave of white intruders and all stripes of anxious settlers eager to grab land, build homes, and establish towns and businesses in what had been the domain of once-proud Native Americans.

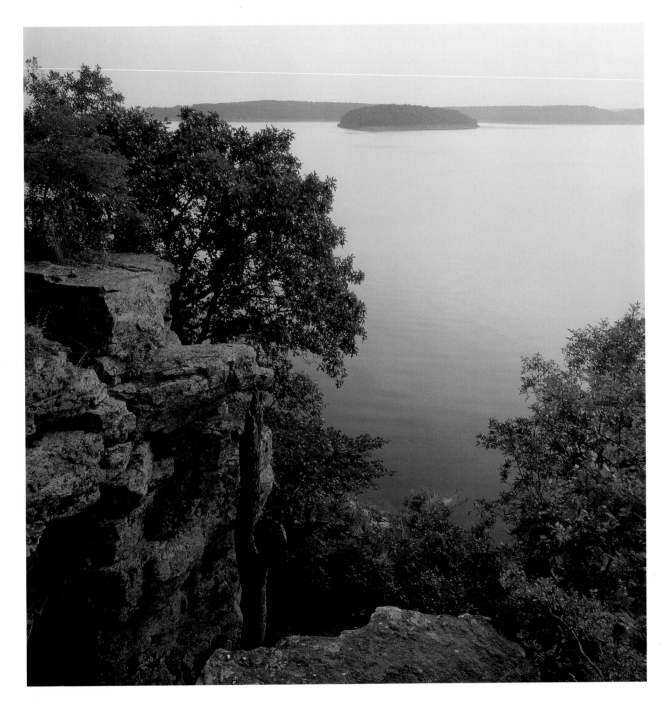

The denial of history did not stop with the coming of statehood, in 1907. Other eras from the past and several specific historical events—including the unscrupulous and sometimes murderous treatment of Native Americans to steal their oil rights, the shameful Tulsa race riot of 1921, and additional acts of sheer bigotry and blatant racial discrimination—also have been purged or swept under the carpet because of the perception that they reflected poorly on the land and its people. But one of the most notable examples of modifying history was the reaction to the Great Depression and the dust-bowl years of the 1930s.

In that bittersweet decade, the nation's economy cracked, and wholesale drought and destruction visited the land. Indelible scars were left on the land and the people. Banks failed and bandits roamed the countryside. After the rain stopped, thick clouds of dust swept across parts of western Oklahoma and neighboring states. The tenant-farming system broke down. A great migration of so-called Okies, Arkies, disenfranchised workers, and vagabonds headed west to rebuild shattered dreams and start new lives in the promised land of California. Many of the refugees and migrants took to the Mother Road, as John Steinbeck called Route 66 in his immortal novel, *The Grapes of Wrath*.

Although Steinbeck's powerful book was praised by a great many Americans, including Eleanor Roosevelt, as a literary work of major social importance, residents of Oklahoma openly attacked it. They believed it cast their state and themselves in a poor light. Inflexible clergymen, corporate farmers, and politicians debunked the book. Steinbeck was denounced on the floor of the United States Congress and was branded a radical. Oklahoma Congressman Lyle Boren, the son of a tenant farmer, openly attacked the novel in the United States House

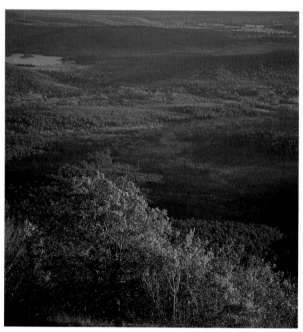

Above: Fall foliage highlights Winding Stair Mountain and Holson Valley as seen from Panorama Vista.
Right: Sunset settles over Cedar Lake.

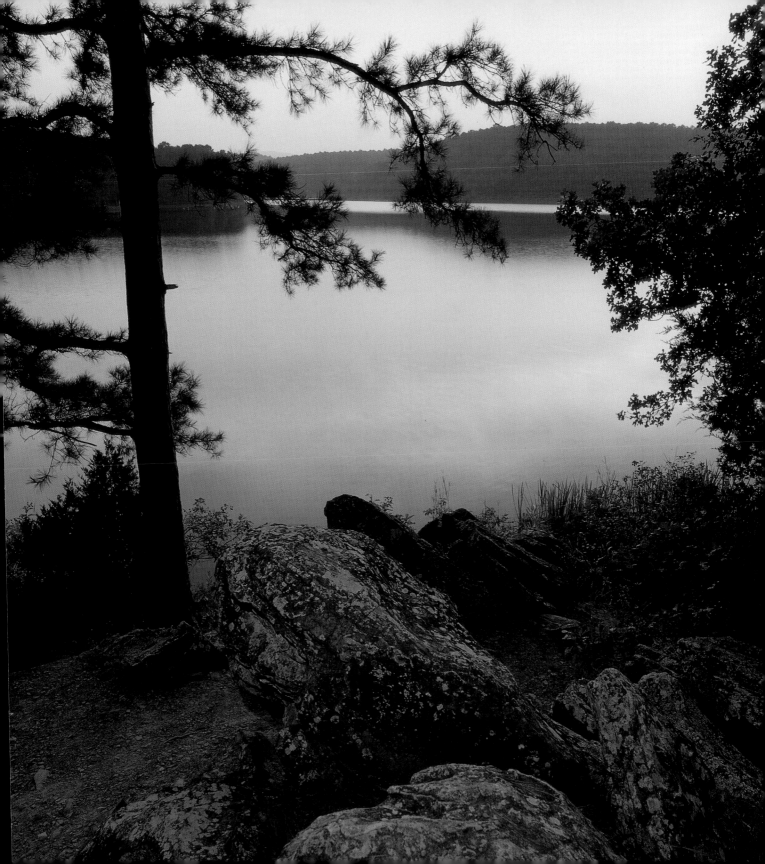

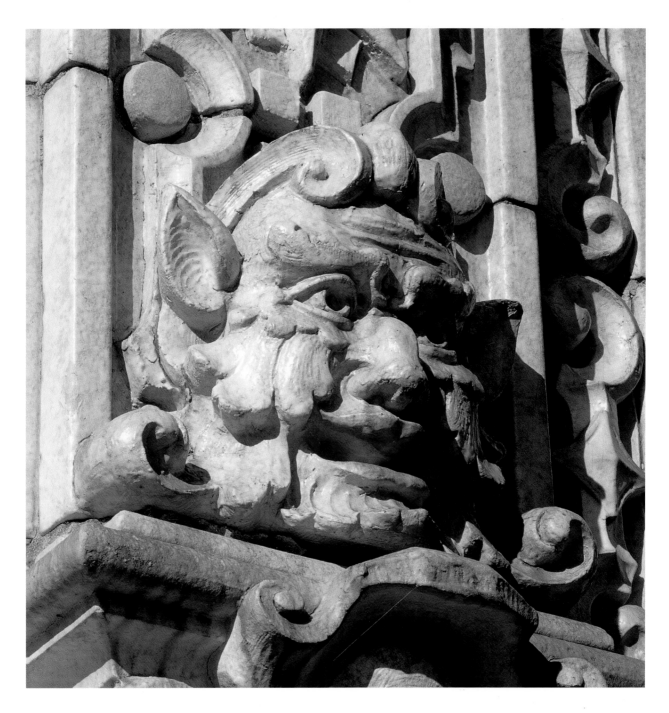

of Representatives, labeling it "a lie, a black, infernal creation of a twisted, distorted mind."

Anxious to find anything to nitpick, many of those Oklahomans pointed out that the true geographic center of the dust bowl was hundreds of miles west of the northeastern section of the state. They complained that the pivotal characters in the book—the fictional Joad family—

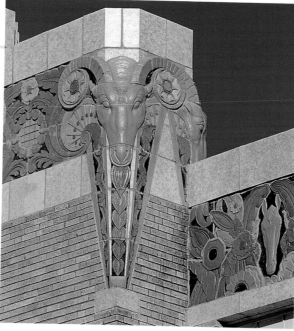

Left: A gargoyle peers out at downtown Tulsa from the elaborate terra-cotta façade of the 1928 Mincks-Adams Hotel, now an office building.
Above: The Tulsa Fairground Pavilion features terra-cotta ornamentation in the form of livestock.

used the name Green Country to refer to the state's distinctive northeastern region.

Although the color of spring and a symbol for hope and everlasting life, green is but one of the dominant colors of this land. With so many layers of history and culture, northeastern Oklahoma is made up of a rainbow of colors, a variety of hues, nuances of light, and hints of shadow.

should have hailed from the parched Oklahoma Panhandle instead of from Sallisaw, in Sequoyah County, near the Arkansas border.

Not only was the novel banned in many places, but the word *Okie* caused many Oklahomans to cringe. Most thought of *Okie* as a contemptuous nickname that symbolized shame and derision. In truth, it should have been considered a badge of courage and resilience.

Years later, an organization calling itself Green Country, Inc., helped offset Oklahoma's dust-bowl image by promoting economic development and tourism in eastern Oklahoma. The concept caught on. The Oklahoma Tourism and Recreation Department

There are the numerous shades of red, tan, white, black, and yellow of the people who have made their homes in the region. And there is the rich color of the Oklahoma crude oil—black gold, as it became known—that helped to lubricate and drive the economy. The soft browns, licorice black, and chestnut colors of the soil are part of the palette. So are the coffee-colored waters of the many rivers, reservoirs, and lakes, the bright blooms of spring, blazing autumn leaves, and the lion-colored grasses of the tallgrass prairie. Ribbons of brilliant neon still light the path along Route 66 and other thoroughfares.

Beyond the kaleidoscope of colors of the land and its people and the fact that some northeastern

Oklahomans deny or ignore their history, the region also is plagued by an identity crisis. Many outsiders and even some residents wonder just where Oklahoma's northeast fits into the general scheme of things. Is it part of the Midwest or part of the Great Plains? Is it western or southwestern?

Perhaps it is some of these. Perhaps it is all of these—and more.

Visitors driving through the shaded residential streets and orderly neighborhoods of Tulsa often comment that it feels as though they are in Connecticut or one of the cities of the upper Midwest or the eastern seaboard. Oklahoma, surrounded by six states, shares its northeastern boundaries with three of those— Kansas, Missouri, and Arkansas. A definite reflection of all three can be found in Oklahoma's northeast.

So can the tangible influence of the rival state of Texas, far to the south—although many red-blooded Oklahomans would prefer to admit kinship to Lucifer rather than acknowledge any link

Left: The Tallgrass Prairie Preserve contains more than four hundred plant, three hundred bird, and eighty mammal species.
Above and below: *Varieties of wildflowers grow around Horse Thief Springs* ***(above),*** *in Ouachita National Forest. The Azalea Festival in Muskogee* ***(below)*** *celebrates spring.*

to that big, brash state across the Red River. Elements of the Lone Star State and the Deep South, especially the culture and lifestyle, exist in northeastern Oklahoma. However, the more sophisticated cities—in particular, Tulsa—which support a variety of businesses sometimes feel much more akin to large corporate metropolitan centers far to the east.

Yet despite the broad range of geographic, cultural, and historic influences from so many other locales, northeastern Oklahoma remains its own uncommon place. And even though past events that strengthened the people's resolve have been ignored and confusion lingers about the region's identity, an alliance with the land—this place called Oklahoma's northeast—has been forged. It appears that the bond will last for a long, long time.

Each eastern Oklahoma locale has its own distinguishing quality and character. Each has been tattooed by the elements and

stamped with the telltale traces of time and space. Each remains special in itself.

One of those special places, unmatched for sheer natural beauty and powerful vistas, lies well to the south of the Arkansas River valley in the southeastern reaches of the region bordering Arkansas. Travelers to this scenic highland retreat are confronted by the Ouachita Mountains, the most extensive range of hills and mountains in Oklahoma. This ancient range, almost four times as old as the Rockies, was born 250 million years ago at the tail end of the Paleozoic era, from the Greek *paleozoic,* meaning "ancient life."

Believed to be an extension of the Appalachians, the Ouachita (pronounced WASH-ih-taw) Mountains stretch westward from Arkansas into three Oklahoma counties —McCurtain, Pushmataha, and Le Flore. Of those three counties, only Le Flore is considered to be part of the so-called Green Country by some people who cling to the use of regional labels.

With elevations ranging from seven hundred to twenty-six hundred feet, the Ouachitas were formed when what became known as Africa still was attached to the east coast of present North America by a series of separate curving limestone ridges. Much later, after humans arrived on the scene, those ridges were given picturesque names such as Sans Bois, Winding Stair, Kiamichi, and Jack Fork Mountains. Considered some of the most rugged topography in Oklahoma, the narrow valleys cut by spring-fed creeks and sandstone ridges—covered with thick pine and hardwood forests nurtured by winter snows and annual drenching rains of spring—posed major obstacles to the development of roads when the first white settlers appeared.

Today's visitors traverse the Talimena Scenic Byway, a fifty-four-mile drive created in the 1960s to link the Oklahoma town of Talihina, the Choctaw word for "iron road," with Mena, Arkansas. The paved corridor, with plenty of sharp curves and steep grades,

◆

Hardwoods and pines reflect a beautiful autumn along Talimena Scenic Drive, viewed from Dead Man Vista in Ouachita National Forest.

winds along the crest of Rich and Winding Stair Mountains, through the heart of the Ouachita National Forest. The panorama of pine, oak, and hickory cloaking the hills and mountain slopes —especially in autumn, when the upland forest terrain shows its true colors—has made Talimena Trail one of the most popular stretches of road in the state.

Still, from time to time, wayfarers through the highlands should get off paved roads and meet the land up close and personal. Walk the land. That was the way it was meant to be experienced. Hike into the pine-carpeted valleys and forests of the Ouachitas or turn farther north to the Sans Bois Mountains, between Fourche Maline Creek and the Arkansas River. The more adventurous visitors may prefer a winter visit, when streams run icy, and the old mountains, cloaked with heavy snows that mask all sounds, stand as mute reminders of ancient times.

Each season in the mountains brings its own rewards. Just being in the company of a family of white-

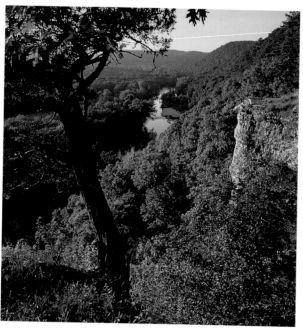

Sparrow Hawk Primitive Area, 566 acres, was donated in 1963 by the Fite family with one stipulation—no roads or power lines would be allowed to cross the area.

◆

tailed deer grazing in the speckled shade of a woodland clearing, or watching the sun disappear behind Blue Mountain from the heights of Poteau Mountain is time well spent. Listening to the ghostly opinions of screech owls in the tall timber at twilight, walking the banks of the Poteau River on its way to join the Arkansas, or working one of the many fishing streams where catfish, crappie, and sunfish reside can be a most potent tonic—a soothing balm that heals and restores bodies and souls better than patent medicine.

It seems fitting that northeastern Oklahoma is protected by the mountains running east to west in timbered ridges in the far south end of the region and by great prairies and ranch grasslands in the north. Between those important natural locales are two other distinct areas—the Ozark Plateau and the Arkansas River valley.

Made up primarily of high hills and sharp bluffs, compact valleys, sparkling streams, and

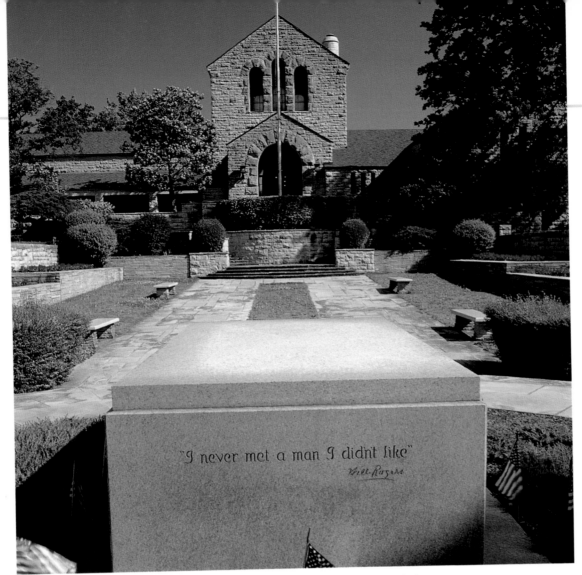

"I never met a man I didn't like"
Will Rogers

The Will Rogers Memorial, on a twenty-acre hillside site, is the final resting place of Rogers, his wife, Betty, and two of their children.

◆

hardwood forests, the low-lying Ozarks overflow from Arkansas and Missouri into northeastern Oklahoma and blend with the prairies and plains.

The sandstone-capped Boston Mountains and the Cookson Hills are the main high spots in this part of Oklahoma's northeast. Anchored by thick beds of shale and sandstone, they form the southern part of the Ozarks which, with the Ouachitas, comprise the only extensive elevations between the Appalachians and the Rockies.

The many streams and the forests of oak, ash, hickory, hard maple, and sycamore in the Ozark Plateau give

northeastern Oklahoma some of its most stunning autumn scenery. And the adjacent Arkansas River valley—a large fan-shaped area of tablelands, farms and towns, and deposits of oil and coal—provides much of the natural wealth.

With its headwaters rising at Tennessee Pass on the eastern slope of the

Colorado Rocky Mountains, the Arkansas River—the largest river which flows into the Mississippi-Missouri system—is fed by glacial lakes and snowmelt before it arrives in northeastern Oklahoma. In Colorado, the river is a white-water stream, running swiftly south and east through deep valleys

The Perryman Cemetery, in residential Tulsa, includes burial sites dating to 1848.

Hominy, "city of murals," reflects the work of local artist Cha' Tullis. He began the murals in 1990.

and canyons, including the famous narrow slot called Royal Gorge, with its suspension bridge—the highest in the world—at 1,053 feet above the rushing river.

But as the Arkansas flows southeast out of Colorado in its long course across the Great Plains of Kansas, it changes its pace and slows down. By the time the Arkansas slips across the Oklahoma border north of Ponca City on its 1,450-mile journey to join the mighty Mississippi, the river is full grown and set in its ways.

To the west, the Arkansas is fed by the Cimarron and Canadian. The chief tributaries from the north and northeast are the Grand, Illinois, and Verdigris, and from the south, the Poteau—Oklahoma's only north-flowing major river. In eastern Oklahoma, the Arkansas—reddish brown from mud, silt, and clay—meanders through wheat fields and prairie towns and flows in a deep but broad valley. A shallow but temperamental ribbon of water prone to devastating floods and rampaging tantrums, the river can be as moody as a nesting water moccasin and just as cruel.

Although it took centuries, human culture finally arrived in the area. With settlement, much of the land was domesticated, and the Arkansas eventually was dammed up, polluted, and tamed. Still, the river never could be broken fully—it remains the most important natural artery of water in the region.

A walk along the sandy shore at Tulsa near where Crow Creek enters the river, flowing over beds of sandstone and shale, sometimes puts visitors in mind of the way things used to be. Beyond the running path, busy with bicyclists and joggers and their leashed

dogs, past the tangles of green-brier, trumpet vines, and brush and the layer of mulberry, salt cedar, willow, and cottonwood trees, visitors can look across the Arkansas and pretend. They can watch a passing flight of migrating geese, snowy egrets, and great blue herons wading near a sandbar, or sandpipers racing over the telltale tracks of raccoons and opossums. Just for a few moments, visitors can block out the distant highway bridges and convince themselves that the river is free and ferocious once more.

The same holds true for all the parts and facets of this land. It always helps to visualize what the various locales must have looked like long ago, before the intrusion of human culture and the coming of roads.

Just as in the tallgrass prairie or the hills and mountains to the south, all of northeastern Oklahoma remains a place where people are free to imagine. They are free to imagine what the land really was like. They can imagine the countryside before the arrival of the first people, nomads and ancient villagers, European adventurers and explorers, con-

Upper: Barges with soybeans, petroleum products, and other commodities travel the McClellan-Kerr Arkansas River Navigation System.
Lower: Tenkiller Ferry Dam, at Tenkiller Crossing, is on the Illinois River near Gore.
Right: Billy Creek is in Ouachita National Forest.

quered Native Americans and their slaves, outlaws, white settlers, farmers and ranchers, oil barons, and all the rest.

Imagine when there was no Tulsa, no Muskogee, no Bartlesville, no cities or towns at all. Imagine what it was like with none of the large lakes and reservoirs—every one of them created by people, and every one of them crowded with noisy powerboats and ringed with commerce. Imagine the land before the coming of the roads, when there were no concrete and asphalt highways and turnpikes. When there were no bingo parlors and smoke shops, no jailhouses, cemeteries, junkyards, and marinas. When there were no steel towers carrying electricity, no sewers, no country clubs, no revival tents and posturing television preachers, no bureaucrats and politicians, no cappuccino and diesel fuel, no cholesterol and credit cards, and no shopping malls.

Imagine when the grassland meadows and the stands of trees along the rivers were the churches and cathedrals. When the mountains, hills, valleys, and hidden hollows near clear creeks were the

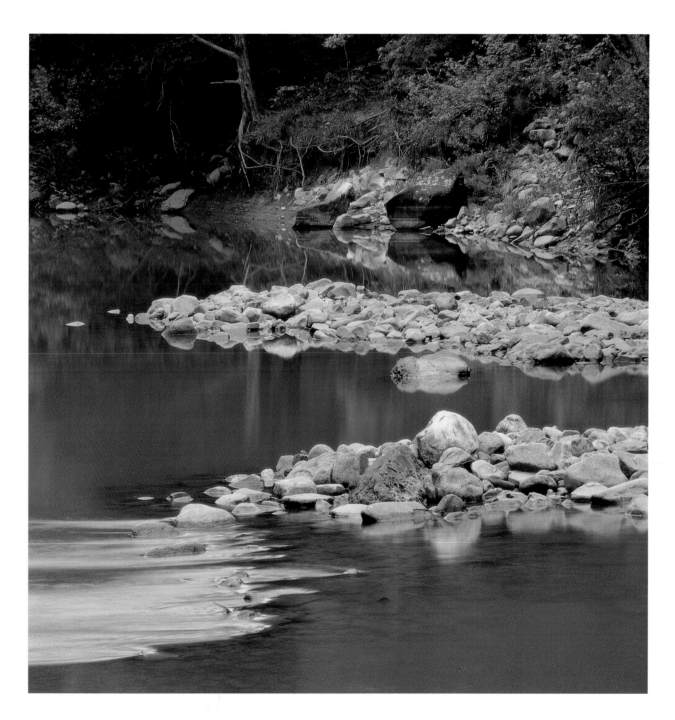

Adams Corner, at Cherokee Heritage Center's Tsa-La-Gi, is named in memory of Blanche Keeler Adams, a Cherokee. Her son, K. A. "Bud" Adams Jr., funded the construction. The relocated log cabin dates from the 1860s.

universities and schools. When the best entertainment came from the elements—prairie light shows, spectacular concerts of thunder and wind.

Imagine when there were no names for the Osage prairies or Winding Stair Mountains or Arkansas River, or for the flowers and trees. Imagine a time before the prominent summits of the Boston Mountains southeast of Tahlequah were given names such as Walkingstick, Sugar, and Welch. This was long, long ago, when the land policed itself with fire and ice, with flood and wind.

Imagine a time without game wardens and park rangers because there was no game—only quarry to provide sustenance for the creatures of the land. Imagine a time when there was no need to explain the butterflies, songbirds, eagles, wolves, and bison, yet everything knew its own identity and its place in the scheme of life. Imagine a time when coyotes—God's own resilient and elusive songdogs—ran free and sang the world into existence.

Today, visitors and residents alike have only an inkling of what the place known as northeastern Oklahoma must have looked like hundreds of years ago—in the misty past before whole species of animals and birds had vanished, before old-growth timber had been logged, before so much natural habitat had been ravaged.

It evolved from being a place where a vast variety of land and life-forms met and mingled—a true transition zone—to become a crossroads for human traffic.

Thankfully, like the rest of the state and so many other places on the continent, there are still

remnants—tattered souvenirs of the past. There are still isolated natural places which survive as a tribute to long ago, when the odds were in favor of the wild creatures. Pockets remain in the Cookson Hills, the Ouachitas, along the Illinois River, on the tallgrass prairie. They survive to teach and remind. They survive to help people understand what they have lost and what still could be lost unless they care—unless they dare to imagine.

Contrary to popular opinion, the human history of the state did not commence with the often romanticized land runs of the late 1800s. Long before the intrusion of Europeans and later Anglo-American culture, a large part of Oklahoma's northeast was populated by Mound Builders and nomadic tribes and other Native Americans—the first peoples who settled the land.

More than a few residents of northeastern Oklahoma and even some historians take for gospel the legend that Viking explorers were the first whites

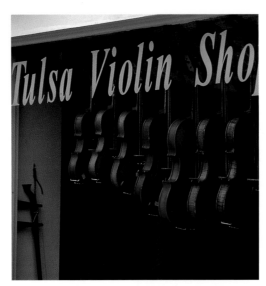

Above: The Tulsa Violin Shop in Brady Arts District is owned by cellist Louis Lynch.
Right: Spring-fed Lake Spavinaw, with seventeen miles of shoreline, provides water for Tulsa.

in Oklahoma. They claim that centuries before Columbus got around to sailing into the history books, a band of stalwart Norsemen somehow found its way hundreds of miles from the nearest ocean to present Le Flore County.

Anyone headed for an autumn cruise through the mountains in those parts who harbors even the slightest doubt that Vikings were there had better keep still about it and not say a word. In the town of Heavener, folks will march any doubters straight to a nearby state park to gawk at what they believe is ample hard evidence that Scandinavian sea rovers did indeed visit Oklahoma at least five hundred years prior to the arrival of the Spanish.

It seems that in 1912, a large slab of Savannah sandstone—measuring twelve feet high, ten feet wide, and about two feet thick—was found in a rocky ravine on the side of Poteau Mountain. Deeply carved into the stone are eight runic letters believed to be part of the Viking alphabet of the eleventh century. In the ensuing years since the Heavener Runestone's discovery, a variety of translations has been offered for the

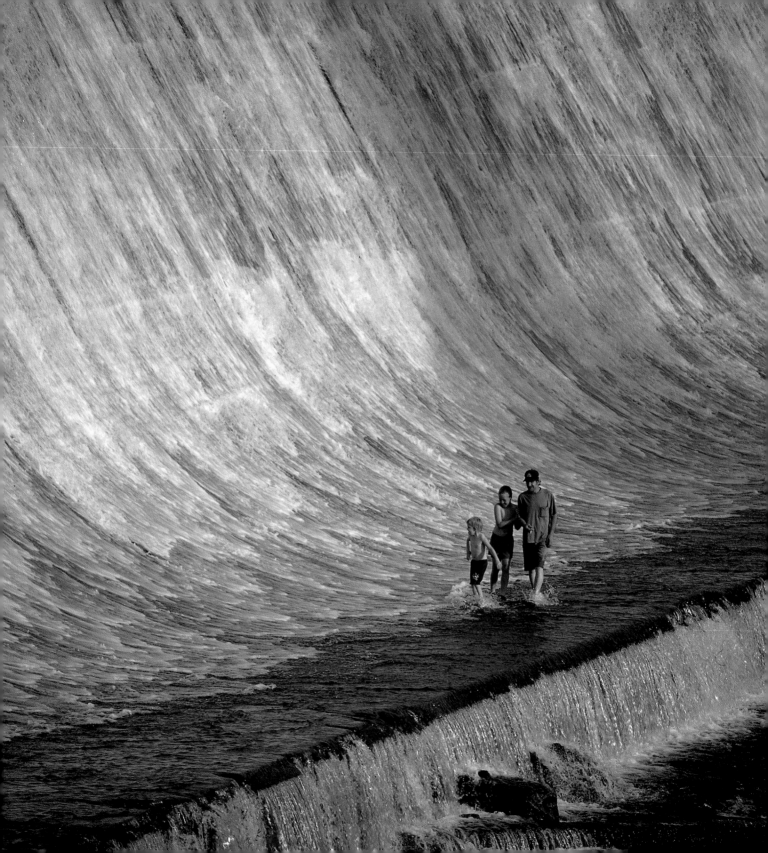

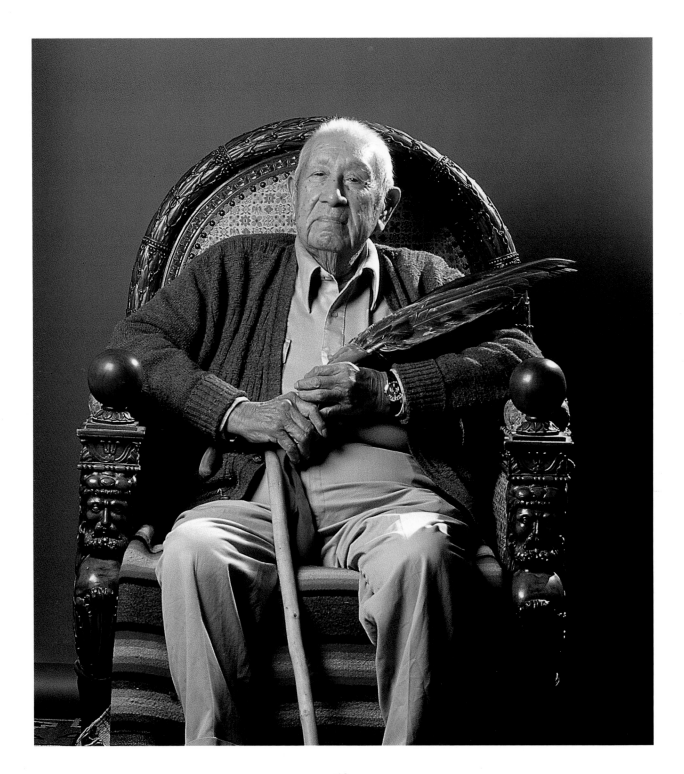

eight characters. The most accepted remains the date "November 11, 1012."

A couple of smaller stones found nearby bear runic script that has been translated as the dates "1017" and "1024," suggesting that whoever did the carvings made several trips to the area. Whether the historic graffiti were left by Vikings or by later settlers probably never will be known. What is known is that eventually European explorers—first the Spanish and then the French—did venture into Oklahoma.

It is always important to bear in mind that although Oklahoma is such a relatively young state compared with much of the rest of the nation, it is really the world's oldest adolescent. Never forget that the original inhabitants of what is now known as Oklahoma appeared thousands of years ago. Although there is still debate over the origins of these predecessors of latter-day Native Americans, evidence of their lives has turned up through the years at several northeastern Oklahoma locations. Historic debris, sometimes in layers at least a dozen feet deep, has been uncovered at ancient campsites along creeks and rivers, near freshwater springs, and in limestone caves and on rock ledges of mountain ranges where people sought refuge during the harsh winter months.

Early people who came to present-day northeastern Oklahoma were foragers with itchy feet that kept them on the move. They wandered the land and tended to travel their own circuits, always in search of game and food supplies and improved campsites. When archaeologists excavated some of those ancient sites, such as the campground unearthed on Fourche Maline Creek in Le Flore County, all sorts of clues were revealed. They included crude weapons and tools, fragments of mussel shells, burned rocks and charcoal, animal bones, stores of seeds and nuts, and flint chips and projectiles.

These restless people roamed the countryside, resided at temporary camps along the streams, and dwelled in cave and ledge homes. Through study and testing of their camp remnants and other key archaeological evidence, a much clearer picture of human development in the region has emerged.

Next came an era known by historians and archaeologists as the age of the Mound Builders, or the "Golden Age of Oklahoma prehistory." Superb engineers, builders, craftsmen, and farmers, the Mound Builders were not limited to Oklahoma. However, their ceremonial center at Spiro Mounds, in the Arkansas River bottomlands of Le Flore County, is one of the best-known sites of that culture. Like those who had come to this area before them, the Mound Builders did not leave written records of their lives and accomplishments, but they unknowingly registered their presence in other ways. Remains of their culture have been retrieved at mounds with baked-clay floors and circular fire pits just a few miles east of what later became the crossroads town of Wagoner—dubbed by journalists in the late 1800s as the "Queen City of the Prairies." Invaluable

Left: Robert A. Whitebird Sr., a full-blooded Quapaw, works to retain tribal traditions and to extend rights afforded to reservation Indians to other Indians in Oklahoma.

relics removed from digs in the Poteau River valley and, during the 1930s, at Spiro Mounds also tell at least part of the Mound Builders' story.

The earthen mounds, shaped like flattopped pyramids, contained carved stone and clay effigies and pipes, cane combs, etched tortoiseshell neck ornaments called gorgets, colorful textiles, ceramic decanters, and cedar and copper masks. The array of utensils, weapons, and implements from Spiro

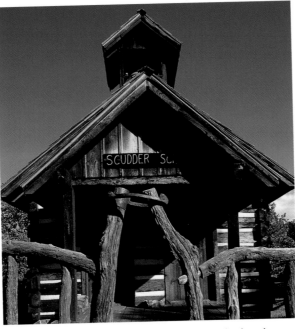

The reconstructed Scudder School, a log building with a horseshoe gate latch, typifies schoolhouses on the prairies in the 1800s. The school is at Prairie Song, northeast of Bartlesville.

has revealed much about those native people and the complex and specialized society they maintained from about A. D. 500 to 1450.

Because of destructive raids by tribal people of the Great Plains to the west and other causes that may remain unknown forever, the advanced civilization of the Mound Builders went into decline. The talented artisans and planters of Spiro and elsewhere in the region largely had vanished by the time the first European explorers entered present Oklahoma.

By about 1541, when those Spaniards trudged through western Oklahoma bearing the cross and the sword in their fruitless quest for gold and silver, it became clear that the "new" land they had "discovered" had been inhabited long before their arrival. The hundreds of thousands of people who originally lived in what eventually became the United States were known as Indians, or Indios, because of the mistaken belief of Christopher Columbus and the early voyagers that the lands they had "found" were part of Asia.

There was, however, a much more suitable descriptive name for the many people who were native to the land. The various tribes and confederations, all of which had their own languages, beliefs, traditions, and remarkably complex social and cultural systems, considered themselves to be the First People. This was a fitting appellation because they were the authentic and original inhabitants of the land, including the region that

became northeastern Oklahoma.

In the sixteenth century, most of Oklahoma's First People lived in villages along the principal rivers—the Red, Arkansas, and Canadian. Many of those tribal people were the ancestors of the Wichitas and Caddos. For several hundred years, the First People tilled the soil and raised tobacco, pumpkins, corn, beans, and other crops. They took fish and turtles from the rivers and creeks and hunted buffalo, deer, and other plentiful forest and prairie game.

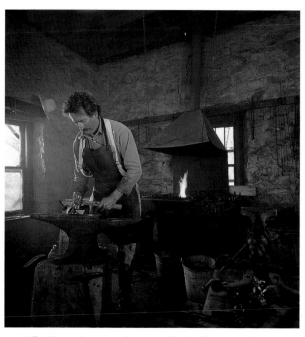

Jeff Briley works over the forge in the blacksmith shop on the ranch of frontiersman and showman Gordon W. "Pawnee Bill" Lillie. Built in 1910, the building was originally a carriage house.

In 1682, Robert Cavelier, sieur de la Salle, floated down the Mississippi and claimed for France all the land drained by the mighty river and its branches. In the seventeenth century, French explorers, trappers, and traders ranged through the region. In the early 1700s, a French party looking for lead deposits made its way from New Orleans up the Mississippi to the Arkansas and on to the Three Forks area in present northeastern Oklahoma, where the Arkansas, Grand, and Verdigris Rivers unite.

By the mid-1500s, Spanish adventurers, driven by greed and the desire to subjugate nature and all human cultures they came upon, marched through the valleys of the Ouachita, Illinois, and Arkansas Rivers, living off the bounty of the earth. But the Spanish had little impact on today's northeastern Oklahoma, where Quapaw farmers and hunters lived in villages near the old Spiro sites and along the lower Arkansas River, and the powerful Plains tribes roamed the hills and tallgrass prairies.

France ruled all of Oklahoma, except for the Panhandle, as part of the Louisiana Province from 1682 until 1762, when Spain again gained control. Once more, the Spaniards had no success. Under pressure by Napoleon Bonaparte, the land passed back into French hands by 1800. The French continued to leave their tracks throughout the land even after 1803, when France sold Oklahoma to the fledgling United States as part of the historic Louisiana Purchase.

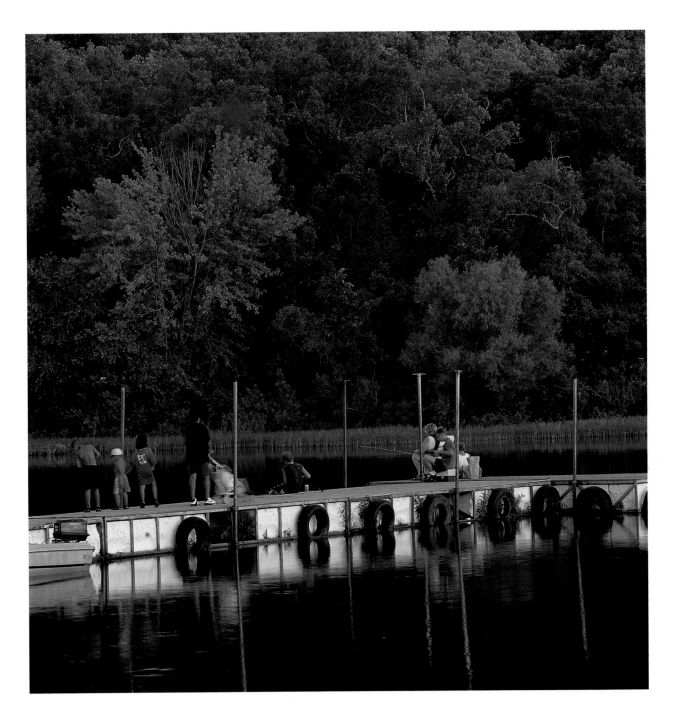

The French added their own descriptions to the written record of what they found in northeastern Oklahoma. One of the more revealing accounts came from the journal kept by Jean-Baptiste Bénard, sieur de la Harpe. In 1719, the intrepid La Harpe led an expedition of *coureurs de bois,* or bush rangers, from New Orleans to several Indian settlements in northeastern Oklahoma. He was impressed by what he and his band encountered—the abundant forests and prairies, the fertile soil, the mineral wealth, but more importantly, the people.

La Harpe not only wrote in glowing terms of the countryside but also of the Wichitas and Caddos, called Taovayas by the French, and the other tribes who lived there. Those skillful Native American traders acted as brokers between the French and the tribes of the southern plains. In exchange for buffalo robes, the French supplied the Comanches and Kiowas with weapons used in raids on Spanish settlements in the Southwest and present Texas. Even hundreds of years before either state

Left: Fishermen enjoy late-afternoon angling at a boat dock at Sallisaw State Park.
Above: The inscription on Fred Olds' statue of Sequoyah, near Sallisaw, reads, "Lo, Great Spirit, Sequoyah conceives the written word in Cherokee." Sequoyah completed his eighty-six-character syllabary in 1821, enabling the Cherokees to read and write their own language.

officially existed, no love was lost between Oklahoma and Texas.

La Harpe's daily chronicle even offers insight into the culinary habits of those early Oklahomans. Their menu was a far cry from barbecued pork ribs, catfish platters, and chicken-fried steak. At one ceremonial bash near the present site of Haskell, an Arkansas River valley town in Muskogee County, more than five thousand Indians assembled at a shady brush arbor to pay homage to their French ally and guest.

The old chiefs washed La Harpe's head and feet, painted his face ultramarine and red, and passed around an ornamented ceremonial pipe, or calumet, which they smoked long into the evening. They also bestowed the newcomer with all manner of gifts, including a cap of eagle plumes, thirty buffalo robes, pieces of rock salt, and chunks of tobacco. For his dining pleasure, La Harpe was presented with an eight-year-old slave girl who had been taken captive from a rival tribe. The horrified Frenchman quickly noticed that the unfortunate child already had

been used as an hors d'oeuvre—a finger was missing from each of her hands.

Stunned by the grisly gesture, La Harpe scribbled in his journal that the host chief "told me that he was sorry to have only one slave to present to me, that if I had arrived sooner he would have given me the seventeen that they had eaten in a public feast. I thanked him for his good will, regretting that I had not arrived in time to save the lives of these poor unfortunates."

The French, the first whites to descend the Arkansas River, prospered. Gradually, the surrounding landscape began to change as tiny settlements appeared near trading centers and later military posts on the frontier. Major Jean Pierre Chouteau, a resourceful and clever man with strong ties to the Osages, and a party of trappers and traders from Saint Louis visited Oklahoma's northeast as early as 1796. A short time later, Chouteau established the first permanent white settlement in what is now Oklahoma. The trading post on the bank of Grand River was named Grand Saline, or La Saline.

Later called Salina, the small Mayes County town which grew into a key point on one of the trails through northeastern Oklahoma still marks Chouteau's birth every October. Some citizens and historians—obviously non-Indians—even have referred reverently to Jean Pierre Chouteau as the "Father of Oklahoma." Only a few miles southwest of Salina is the trading-center town Chouteau, which sprang up with the coming of the railroad in the early

1870s and was named in honor of the Chouteau family.

Besides Chouteau and Salina, many other common place names in Oklahoma's northeast came from the French, such as Verdigris, Sallisaw, Illinois, Vian, and Grand. All of those names remain prominent in the lives of people today, although most of the French words have been given their own Oklahoma pronunciations.

The French influence does not stop with place names. Among some of the tens of thousands of Native Americans living in northeastern Oklahoma, especially members of the Osage tribe, French surnames still can be found. The blending of Indian and French blood or the fusion of any of the independent cultures found in Oklahoma's northeast continued to pay off in handsome dividends that became evident far into the future.

A Chouteau descendant—the gifted and elegant Yvonne Chouteau, of Shawnee lineage and listed on the Cherokee tribal rolls—became one of the internationally acclaimed Native American prima ballerinas of the twentieth century. Chouteau was the youngest American ballerina ever accepted for the prestigious Ballet Russe de Monte Carlo. She and the other American Indian dancers—Maria Tallchief, at one time the ranking ballerina in the United States; her sister, Marjorie Tallchief; Rosella Hightower, a Choctaw; and Moscelyne Larkin, of Peoria-Shawnee heritage—all have contributed to the world of dance.

Those graceful ballerinas have left enduring prints in their native soil, as did their ancestors—the people of the forests and

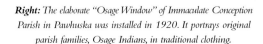

Right: The elaborate "Osage Window" of Immaculate Conception Parish in Pawhuska was installed in 1920. It portrays original parish families, Osage Indians, in traditional clothing.

IN MEMORY OF STEPHEN NEAL, BY MRS. ROSA NEAL HILL.

IN MEMORY OF BONNICASTLE FAMILY.

IN MEMORY OF MARGARET ET CUNGHAM.

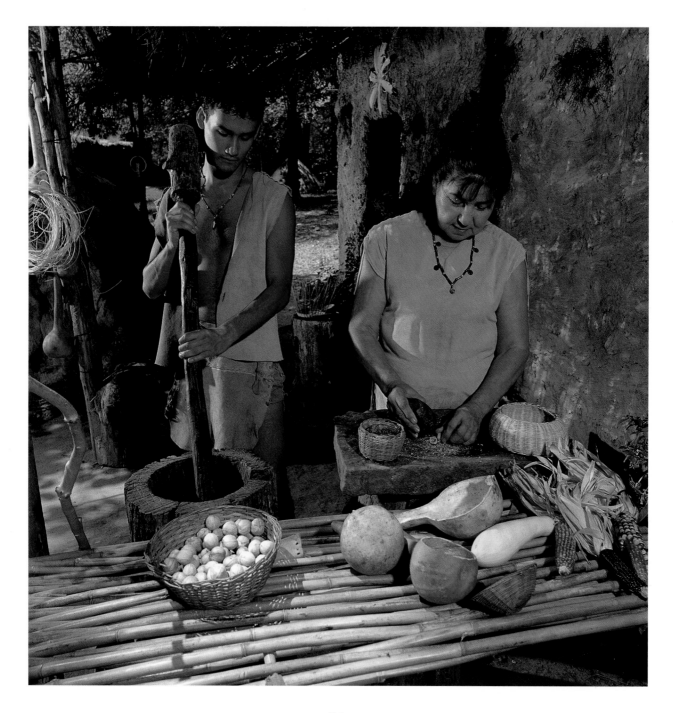

prairies, in feather cloaks and turtle-shell shackles, who danced to coax the crops from the earth and bring the rain from the heavens. By firelight, with hearts and drums keeping time, they danced for pleasure, for their deities, for the promise of the seasons, for the spirits of the living and the dead.

People from several tribes remain active and vital participants in today's world, but they also maintain ties to the dead magicians, the keepers of wisdom, and the kinfolk who came before them. In Oklahoma's northeast, there are clans that continue to dance to the pulse of drum and gourd rattle, just as their ancestors did before the coming of government soldiers, meddlesome missionaries, and Indian boarding-school teachers—all of them intent on altering and, if possible, destroying the Native American way of life.

Old men and women, young boys and girls still meet at ancient stomp grounds and hallowed places. Sometimes these native people are from many tribes. They gather to dance and celebrate together beneath a heaven crowded with stars and high hopes. Tents are erected near the clan arbors, and the smell of

Left: Lena Blackbird and Kevin Workman demonstrate the making of kanatsi, *hickory-nut soup, in the ancient Cherokee village at Tsa-La-Gi, near Tahlequah.*
Above: The Western Cherokee capital at Tahlonteeskee was named for a Cherokee chief who, in the early 1800s, led a band of three hundred people from the East to Indian Territory. This council house and courthouse are replicas.

smoke from cooking fires saturates the night air. They sing and chant and move as one in timeless circles around a sacred fire. They keep the rhythms of life. They preserve and protect. They bear witness for those who are no longer here to defend themselves. They dance on and on. They never forget.

All of them—stomp dancers and graceful ballerinas alike —have left behind bits and pieces of themselves. All of them have become part of the fiber and fabric of this place. The many Native American tribes—those which resided in this land of their own free will and those which were removed forcibly to Indian Territory—were by far the greatest contributors. For that reason alone, the name for the forty-sixth state is especially fitting— the word *Oklahoma* comes from a Choctaw phrase meaning "red people."

Although Oklahoma did not become a state until 1907, the national banners of fourteen governments

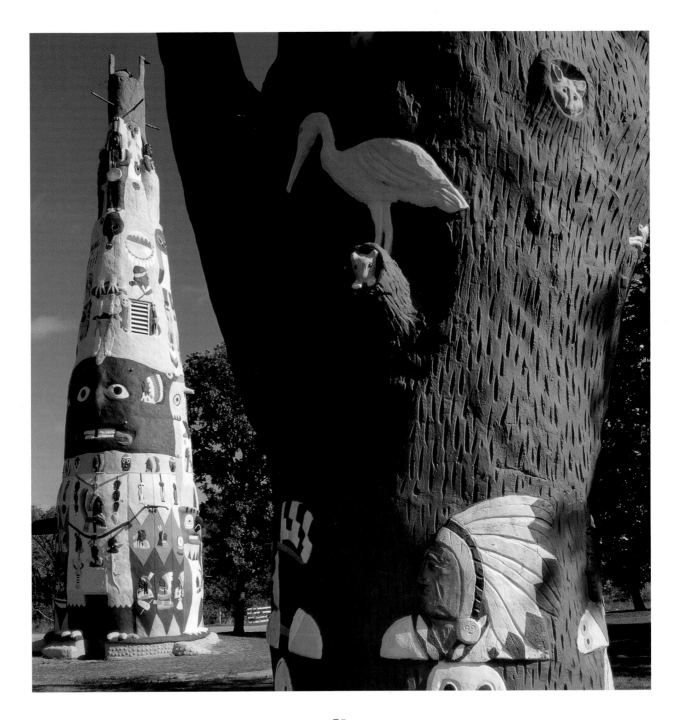

flew over parts of the state at one time or another, including the flags of Spain, Great Britain, France, Mexico, the Republic of Texas, the Indian Nations, and the Confederate States of America.

The flags represented men and women of all types and persuasions, shades and colors, faiths and opinions. They hailed from faraway lands and nearby places. They forded swollen streams and traversed the countryside—the timberlands, the prairies with grass so tall it could hide a horseman, and the steadfast mountains and hills. They carved trails and passageways across the landscape. Some of them were on the run from the law or from themselves. Some took all they could from the land. Others lost all they possessed or ever hoped to have, even their lives. Many of those who perished were far too young.

Often, they only were passing through on their way to someplace else. Sometimes, out of choice or chance, they remained. They built homes, churches, schools, businesses, and towns. Or perhaps they left nothing but an inconspicuous trail in the prairie sod.

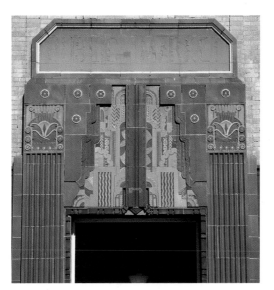

Left: The famous totem poles near Foyil, built by Ed Galloway, are as high as ninety feet and are made of concrete and steel.
Above: The main entrance of the old Tulsa Warehouse Market building once led to Club Lido, where jazz bands of the 1930s and 1940s played.

One of those early trailblazers was Nathaniel Pryor, a Virginian who had served as a scout with the famed Lewis and Clark expedition and later, in the War of 1812, as an officer at the Battle of New Orleans. In 1819, after receiving his discharge from the army, Pryor came to the Three Forks region. He took an Osage wife, mastered her language, and established a trading post near the mouth of the Verdigris River. Later, he became an Indian agent and built another trading post just southeast of what became the town of Pryor, the seat of Mayes County, on a creek also named for him. He died in 1830.

Although the Osages regarded Pryor highly, he never attained a full measure of success as a merchant. Refused a pension from the government he had served, the old warrior died penniless. The fact is, only a few of those first white Americans and Europeans who made northeastern Oklahoma a destination ever found fame and fortune. Most of them did not. Nonetheless, all of them—famous and infamous, celebrated and ordinary—are worth remembering. It is important to contemplate

at least a few of those intrepid wanderers who, at one time or another, made the journey through Oklahoma's northeast.

Thomas Nuttall is an excellent candidate for consideration. In 1819, just about the time Captain Nat Pryor was getting to know the territory, Nuttall, a scholarly Englishman who later became a professor of botany at Harvard, arrived at Belle Point, in far western Arkansas. Later known as Fort Smith, the military outpost was established on the brink of Indian Territory to guard the frontier and preserve peace among various Native American tribes and lawless whites who sought haven there.

The American Philosophical Society sponsored Nuttall's trip into what is now Oklahoma—a region that many people of that time considered ominous and inhospitable. Escorted by a company of soldiers, who also were on the lookout for white squatters to boot out of Indian lands, Nuttall explored large parts of northeastern Oklahoma. He followed the Poteau and Kiamichi Rivers and traveled the Arkansas to the Verdigris. From the Three Forks area, he investigated the Grand River, visited a commercial saltworks in present Mayes County, and walked through the tall grasses of the stunning Osage prairie.

Although the stouthearted botanist endured many hardships and almost succumbed to a pesky fever, he survived to publish, in 1821, a journal of his travels. Nuttall's detailed account of the Oklahoma flora and fauna as he found it—before the southeastern tribes had arrived with their elements of white lifestyle—still is thought to be one of the most useful and complete guides to the natural resources and people of Oklahoma.

The Indian encampments, assortment of creatures, and natural beauty of the Kiamichi Mountains left the scholar in awe. Nuttall wrote, "Nothing could at this season exceed the beauty of these plains, enameled with such an uncommon variety of flowers of vivid tints, possessing all the beauty of tropical productions." He pronounced the prairies "delightful" and described the melody of a mockingbird as "the most wild, varied, and pathetic, that ever I had heard

Nelson's Buffeteria, founded in Tulsa in 1929 by Nelson Rogers Sr., is known for chicken-fried steak, the Nelle burger, and the super donut.

from anything less human."

Anyone who has visited the Osage or has sat on a porch and listened to the summertime solo of a mockingbird at dusk realizes that such descriptions remain appropriate to this day.

So do many of the accounts of this place penned long ago by Washington Irving, the first travel writer to set foot in today's northeastern Oklahoma. Irving, a literary superstar of his

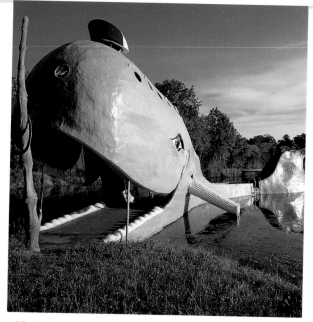

The blue whale has been docked for years along Route 66 near Catoosa. It originally was partnered with a reptile farm. Similar eccentricities can still to be found along Route 66 across the state.

as an "immense extent of grassy, undulating, or, as it is termed, rolling country, with here and there a clump of trees, dimly seen in the distance like a ship at sea; the landscape deriving sublimity from its vastness and simplicity."

But Irving did not limit his descriptions to the physical details of the place— the buffalo and horse hunts, the groves of elms "fringed with tufts of mystic mistletoe," the feasts of wild

time probably best remembered for his short stories "Rip Van Winkle" and "The Legend of Sleepy Hollow," reached Fort Gibson in early October of 1832. The famous author and some European pals had made their way to Indian Territory by steamboat, wagon, and horseback. Irving stayed only about a month, but he made the best use of his time.

Irving's keen observations, first published in 1835 as *A Tour of the Prairies*, give today's visitors and residents an important peek at northeastern Oklahoma when it largely was unspoiled. Irving wrote of the forests, the profusion of wildlife, and the prairie, which he described

honey and venison. He also wrote of the cultures his party found. He described the Pawnees and their celestial legends, the costumes of the Creeks, and the "graceful attitudes and expressive gestures" of a party of Osage warriors in colorful frocks and fringed leggings of deerskin.

The words of Washington Irving still ring true, giving his readers of today a glimpse of early northeastern Oklahoma. For everything about the land and the people who dwelled there was about to change by the time the caravan of explorers, soldiers, traders, botanists, and chroniclers such as Irving found its way to Oklahoma's northeast.

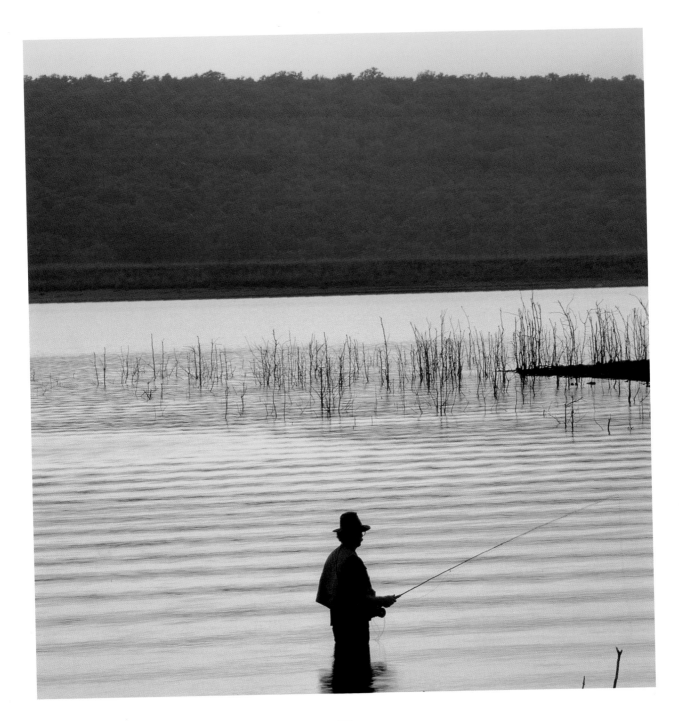

Almost all of the future state of Oklahoma, especially the eastern half, quickly was becoming a warehouse for Native American people from across the country. As early as 1804, President Thomas Jefferson, with congressional authorization, had begun to negotiate with eastern tribes to cede their homelands to the federal government in exchange for new lands in Indian Territory. By 1825, the white men's government had induced the Quapaw and Osage tribes to relinquish much of their land to make room for displaced tribes from the southeastern United States.

Under the rule of President Andrew Jackson, the forced removal of those tribes not only became federal policy but also a cruel reality for many thousands of persons. As a result of the Indian Removal Act of 1830, numerous tribes eventually lost their homes and farms and were relocated to the huge parcel of land that is today's Oklahoma.

The white leaders looked the tribal leaders straight in the eye and vowed that the new Indian lands would be held in perpetuity for the tribes, or to borrow the commonly used treaty phrase, "as long as grass shall grow and rivers run." It was unfortunate that the Native Americans could not look into the white officials' hearts.

Some of the southeastern tribes decided it was in their best interests to play according to the white Establishment's rules. Some of those tribes adopted the white people's religion, government, schools, and lifestyle. They were certain that they would receive more consideration from the whites than other Native Americans who stubbornly clung to their own ways of life. That was not to be the case. The ploy failed for the Cherokee, Creek, Choctaw, Chickasaw, and Seminole tribes—designated as the "Five Civilized Tribes," a pejorative term still in common use.

Removal of the Five Tribes stretched through more than twenty years of chaos, pain, and broken treaties. The routes—overland and by water—which these tribes followed to Oklahoma became known as the Trails of Tears. Of the Five Tribes, the Cherokees, Creeks, and Choctaws ended up with lands in northeastern Oklahoma, and the

Left: A fisherman enjoys late-evening solitude at Tall Chief Cove on Lake Skiatook.
Above: Reenactors represent participants in the Battle of Honey Springs, the largest Civil War battle in Indian Territory, fought near present Rentiesville on July 17, 1863.

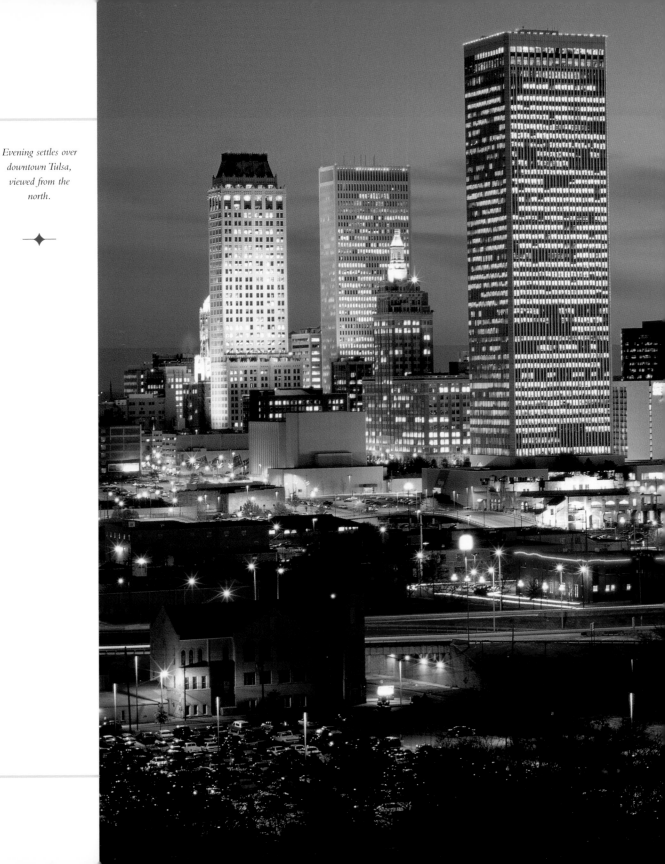

Evening settles over downtown Tulsa, viewed from the north.

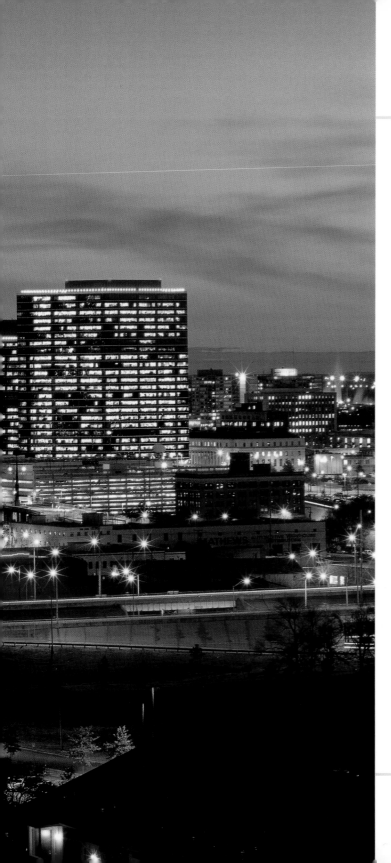

Chickasaws and Seminoles received lands farther to the south.

Because slavery was one of the white institutions the Five Tribes had adopted, significant numbers of blacks—some of them slaves and others free people—also made the horrific treks to "the Nations" along with full-blooded and mixed-blood tribal members. As a result, African-American pioneers helped to shape the state and region and added a notable texture to the land.

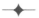

In some ways, those First People, as well as the others who followed them, would not recognize their surroundings today. If somehow the old chiefs and shamans found a way to return, they most likely would want to go right back where they came from. They would take only one look and they would weep.

Yet much beauty and some vital historical and cultural offerings still can be found. The entire region—from the vestiges of prairie in the north to the mountains far to the south—is replete with a hodgepodge of places from the layers of time which persist to this day. These places help to recount the priceless story of the land and its contents. They endure as monuments to all those people who have claimed northeastern Oklahoma as their home.

Many of the locales and sites are natural places. Others were shaped by the contemporary people of northeastern Oklahoma and by those who came before them—Native American farmers and hunters,

former slaves anxious for a better way of life, defeated Confederate soldiers, land-hungry homesteaders, outlaws on the run, cowboys and cowgirls trailing endless herds of cattle, and oil barons who smelled lively pools of black gold percolating beneath the prairie sod.

There also are attractions that represent a combination of natural and human influences. The countryside is covered with lakes and reservoirs which people have created from rivers and streams. And there are many parks and preserves that they have carved from forest and prairie.

No matter how the places came to be, nearly all the northeastern Oklahoma attractions are the important and predictable historic sites, depositories of culture, examples of commercial archaeology, and local landmarks that are likely to appear in standard guidebooks and tourism brochures.

But sometimes, accidentally or by design, the chambers of commerce and other promoters fail to mention the special places—those sites of nuance and subtlety and, very often, of hidden value. Some of those spots are not only special but just may be extra special. All of them—from the humble to the grand—are worthy of a visit.

To take in the abundance of standard attractions and to ferret out and make time for the hidden or forgotten special places, visitors may launch their journey anywhere they wish. Such a pilgrimage offers a broad assortment of options. Some folks may decide to start a canoe jaunt

down the Illinois River. Others may opt for a cruise along the historic Route 66 corridor—a passageway of time and space that acts as a concrete and asphalt backbone for the region.

But for many of the visitors to Oklahoma's northeast, the most ideal starting point is Tulsa—the largest hub in the region and the second-largest city in the state. Tulsa easily can serve as a base camp for anyone interested in uncovering the past and discovering the present.

A strikingly handsome city surrounded by a burgeoning metropolitan area and imbued with plenty of civic pride and corporate muscle, Tulsa long has acted as a mirror for the rest of northeastern Oklahoma. Like the region it reflects, Tulsa revels in its rich heritage, but unfortunately, in the natural desire to progress, Tulsans often overlook the complex legacy that helped to create their city and to invigorate northeastern Oklahoma.

As they consider the legions of risk takers who preceded them, Tulsans must remember to tend to their history—all of their history. That includes not only the good, bad, and ugly, but also the history that occurred before the white Establishment took over the reins of power. To paraphrase a down-home adage, Tulsans never should forget "who brung them to the dance." It is important to remember that there have been several versions of the place that came to be called Tulsa. Each of those incarnations, every single rendition, represents a slice of the pie, a piece of the mirror. Each one stands alone but also unquestionably deserves to be counted with the whole.

◆

Left: Gilcrease Museum's 440-acre grounds include the Thomas Gilcrease home and historic theme gardens, natural meadows, and woodlands.

Tulsa's first citizens were Creek Indian settlers. There is no denying that there never would have been a Tulsa without them. The Creeks were the first ones to breathe life into what became the vibrant city on a bend in the Arkansas River.

Yet a majority of Tulsans erroneously believe the city's birth occurred on January 18, 1898. That was the landmark date when a delegation of nine local men journeyed to the federal courthouse at Muskogee, Indian Territory, to sign charter papers that officially incorporated Tulsa as a city. No getting around it, the incorporation was an important event, but the reality is that a large number of Creeks considered Tulsa their new home more than sixty years earlier.

Some Creeks had been in the area since the late 1820s. They came even before the federal government uprooted their tribe from its homes and farms in the southeastern United States and forced the Five Tribes to move west.

After refusing to join the voluntary exodus to Indian Territory, a band of 630 Creek men, women, and children—all members of the Lochapoka clan—finally were forced to leave their homeland on the north side of the Tallapoosa River in Alabama. Led by Achee Yahola, the clan's principal chief, and escorted by soldier guards, the Creeks began their arduous trek westward in 1834, first by steamboat and then on foot.

With each passing day, the journey became more difficult. Meager rations ran out, and disease and the elements took a heavy toll. Ultimately, the Lochapokas reached Fort Gibson. From there, they continued up the Arkansas to the land set aside for them by the white

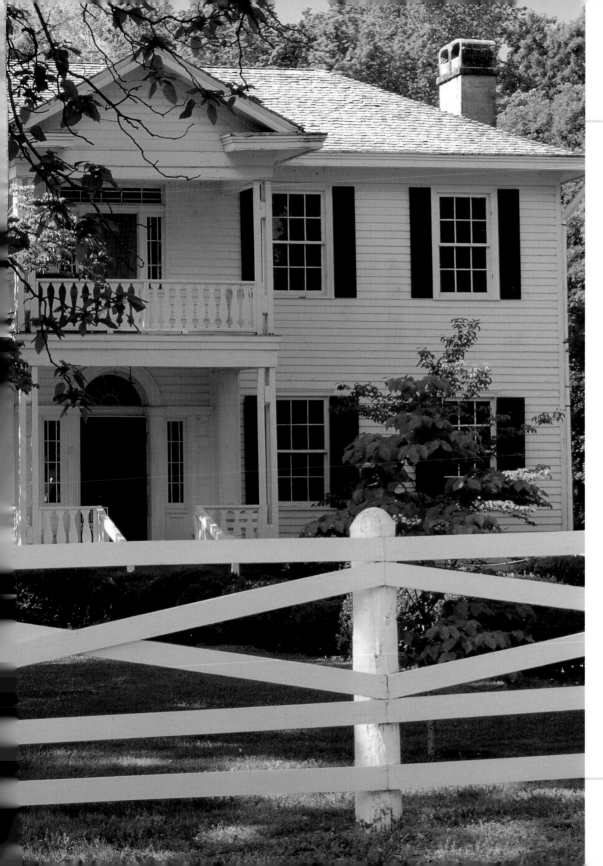

The Murrell Home, at Park Hill, near Tahlequah, has been restored and furnished to reflect the period in which it was built, 1844-1845. It is the only substantial house in Indian Territory to survive the Civil War. Originally known as Hunter's Home, it was built by George M. Murrell, whose first and second wives (sisters) were nieces of Cherokee Chief John Ross.

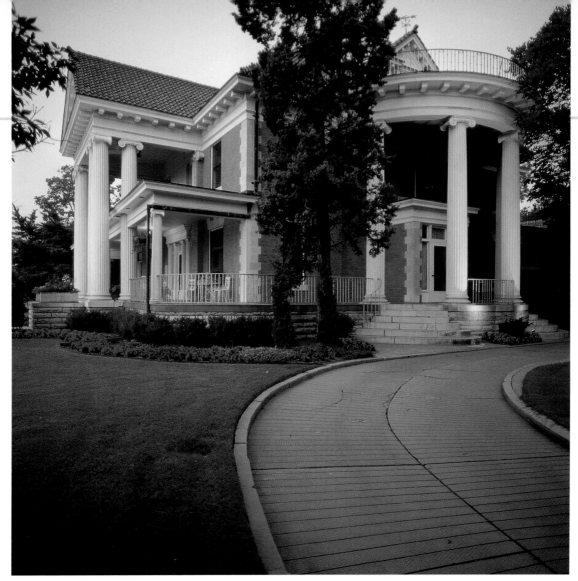

The twenty-six-room Greek Revival–style home of Phillips Petroleum founder Frank Phillips, in Bartlesville, was built in 1909 and is filled with 1930s furnishings.

◆

government. By the time the cruel forced march of the Creeks had ended and they reached their final destination, 161 members of the clan had perished.

In 1836—after almost two years of tears and suffering—Achee Yahola and the survivors from his proud band of Lochapokas trudged up a low rise overlooking the east bank of the broad Arkansas River. Gathered on the crest of that wooded hill with a commanding view of the surrounding countryside, the Creeks remembered family members and friends they had left buried along the trail. They glimpsed into the future and gave thanks—their journey of sorrow had come to an end.

"This is our new home," Achee Yahola was said to have told his people. Beneath the boughs of a sturdy oak, the chief and his followers deposited the ashes they had carried from their last campfire in Alabama. Then, as darkness fell, they took a flint and kindled a new council fire. At that instant, with long shadows dancing in the glow of fresh flames sparked from the ashes and coals, Tulsa was created.

"It was a strange beginning for a modern city—the flickering fire, the silent valley, the dark intent

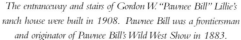

The entranceway and stairs of Gordon W. "Pawnee Bill" Lillie's ranch house were built in 1908. Pawnee Bill was a frontiersman and originator of Pawnee Bill's Wild West Show in 1883.

faces, and the wild cadence of ritual," historian Angie Debo wrote many years later of that brief shining moment.

All sorts of stories and legends survive about how the name Tulsa came to be. It is certain the word is of Creek origin, and most people agree that the new settlement was named after an old Creek town back in Alabama. Still, there is little agreement—even among the Creeks—about the exact source of the name. Some of the most popular choices include *Tulwaahaafe*, or "meeting place," *Tullahassee* or *Tallahassee*, meaning "old town," and *Tallasi* or *Tulwa*, both Creek words for "town."

The Praying Hands *sculpture, by Leonard McMurry, dominates the entrance of Oral Roberts University in Tulsa.*

No matter if it was one of those words or a contraction of the Creek names, eventually the town came to be commonly referred to as Tulsee or Tulsey, most often with the word *Town* as an appendage.

Although kinfolk of those first Tulsans still live and work in the area, the only memories and tangible remnants of the early Creek settlers have been entrusted to museums and family collections. Log buildings that lined the original town square disappeared long ago. The cabin of Achee Yahola, who died in 1850 during a smallpox epidemic, was destroyed, and the location of the chief's grave has been forgotten.

The old tree where Tulsa was born survives, however. It is a post oak, *Quercus stellata*, thick and gnarled, with stout limbs and shiny leaves. It is the kind of tree commonly used in northeastern Oklahoma for construction timbers, railroad crossties, fence posts, and for smoking meat. Old-timers believed the old tree in Tulsa grew larger than most post oaks because of a nearby spring. Others credit the tree's longevity to more divine sources.

Located at Eighteenth Street and Cheyenne Avenue, the Creek Council Oak—as the revered tree has become known— remains the focal point of those original Creek ceremonial grounds.

It is not the city's largest or most attractive tree—that distinction could go to several other worthy candidates, including, some might say, a monumental catalpa shading a yard on Terwilleger Boulevard near Tulsa Garden Center and an adjoining arboretum. Undoubtedly, if the fictional jungle hero Tarzan ever

decided to reside in Tulsa, the lithe acrobat would roost in that lofty catalpa, with its smooth limbs, bell-shaped blooms, cigarlike fruit, and broad leaves.

Comparison of age and appearance aside, the three-hundred-year-old Creek Council Oak has earned its own unchallenged place in history. As long as this tree stands, deeply rooted in the Oklahoma soil, it will symbolize the perseverance and strength of Tulsa's founders. Many Tulsans brag that the tree and the remaining small piece of land around it are the cornerstone of their city and the region.

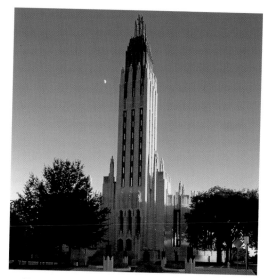

Boston Avenue United Methodist Church is one of the finest buildings in Tulsa. People can't agree on who designed it—renowned architect Bruce Goff, his teacher Adah Robinson, or both.

Visitors should begin their sojourn through the city by paying their respects to this great oak which was Tulsa's first conference room, first church, first town hall, and first court of law. The tree and the adjacent well-trodden town-square grounds—now covered by a grassy lawn—were where chiefs and clan leaders conducted business and where ceremonial dances, rituals, and elections were held.

The site also was where justice sometimes was dispensed. Tribal members who violated Creek laws and were rounded up by the tribe's lighthorsemen could count on receiving lashes under the oak or were tied to its trunk to serve time, exposed to the often fickle weather. Eventually, another trusty oak—even larger than the Creek Council Oak and more than likely a tad older—on North Lawton Avenue, between First and Archer Streets, was designated as the official Creek "hanging tree" for Tulsey Town. It is fitting that capital crimes were dealt with at a site other than the tree on the hill, which represented new life for a vanquished people.

Through the years, the Creeks' beloved council oak has survived many owners, including corporate captains, the Oral Roberts Evangelistic Association, and a Texan who had the gall to contemplate making the historic site into a parking lot, a fate that continues to befall many other Tulsa treasures. Although it has become hemmed in by encroaching newcomers from the different cultures that now reside in Tulsa, the historic oak was spared because of the hue and cry from outraged citizens, historians, preservationists, and the Creek Nation.

Across the street from the small park where the tree abides sits a stately Colonial Revival–style residence which—just like the council oak—has been placed on

the National Register of Historic Places. The white frame house with dormer windows, blue shutters, and beds of irises and begonias was built in 1912 by James Alexander Veasey, an early Tulsa lawyer and the founder of Holland Hall, a fancy local prep school. Air conditioners purr in the windows and an old-fashioned television antenna—a relic from another era—clings like metallic ivy to one of the twin brick chimneys.

Creeks still gathered under the neighboring oak for their ceremonials when Veasey built the house. Some folks claimed the echo of Creek drums and chanting dancers could be heard along the Arkansas even a few years later, when several oil tycoons began to erect mansions in the area.

Although the drums have been stilled, the council fires have gone cold, and houses and apartment buildings dominate the neighborhood, the oak has not been overlooked. Lightning rods have been fitted discreetly in

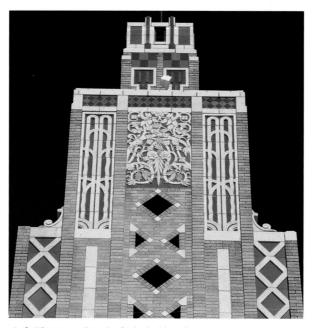

Left: The National Bank of Tulsa building (foreground) was built in 1918. The Cosden building, Tulsa's first skyscraper when it was finished in 1918, originally had sixteen floors. Twenty more have been added.
Above: The tower of the Tulsa Warehouse Market building, designed in 1929 by B. Gaylor Noftsger, is noted for its brilliant terra-cotta decorations.

the upper limbs, and a neat iron fence surrounds the tree. An automatic sprinkler system kicks on each morning during the dry summer months.

Nearby, a manicured plot is planted with traditional herbs, vegetables, trees, and shrubs used by the Creeks for food, fiber, and medicinal purposes. The traditional garden includes corn, cotton, tobacco, spicebush, indigo, pumpkin, and wild strawberry. There are clumps of sumac and redbud and cedar trees. Hundreds of songbirds have nested in the oak's branches. Younger versions of the council oak—all from acorns and saplings born of the mother tree—have been planted in several city parks.

If visitors are lucky enough to make their way to the tree while it still stands, they should consider its significance. If they come in later years, after the tree is but a memory, they still can pay their respects to what used to be. It is clearly a sacred place. It always will be a place for those who dare to dream.

Other extra special places from the various layers of history can be found in Tulsa. Each of them is tailor-made for visionaries and for those interested in gleaning invaluable lessons from the past which can be put to good use today.

History lives in many of the old burying grounds of the Tulsa area, such as Clinton Oaks, Grayson Cemetery, and Tullahassee Creek Indian Cemetery, surrounded by a shopping-plaza parking lot in the nearby industrial community of Sand Springs.

One of the best classrooms in Tulsa is Perryman Cemetery, at Thirty-second Street and Utica Avenue in a sedate residential neighborhood. This small plot of ground—roughly 150 feet by 150 feet—is the city's oldest continuously occupied tract of land. It was laid out in 1848 by Lewis Perryman, a prominent Creek Nation rancher and trader. Despite what some history books proclaim, Perryman was Tulsa's first merchant. He did a thriving business in the settlement, exchanging farm tools, sugar, coffee, and bolts of calico for venison, turkey, animal pelts, and sacks of pecans and hickory nuts.

Wealthy mixed-blood slave owners with a Welsh surname, the Perrymans were part of a contingency of Creeks which left Alabama and Georgia after the assassination of their political leader, Chief William McIntosh. They arrived in Indian Territory in 1828, several years before the Lochapoka band kindled its council fire. By the 1840s, the Perryman family had established a sizable ranching complex in "Tallahassee"

on Crow Creek, in the southwest corner of what eventually became a modern Tulsa park.

During the Civil War, Lewis Perryman, his four wives, and many of their children moved to Kansas for Union protection. After Perryman's death in a refugee camp, his son George returned to Tulsey Town and helped rebuild the family empire, including a sprawling ranch which stretched from about Twenty-first to Seventy-first Streets and from the Arkansas River to Broken Arrow. In 1877, the Perrymans erected a large house at what is now Thirty-eighth Street and Troost Avenue. By 1879, the trading post at the Perrymans' "White House," as it was known, became the first post office in what then was designated officially as "Tulsa." Josiah Perryman, George's brother, was the first postmaster. The Perrymans and the other Creek settlers stimulated the rapid growth of the area and literally put Tulsa on the map.

The first post office, which gave the city its ultimate name, and most of the other old haunts of those Creek settlers vanished long ago. Only a stone marker on the north side of Forty-first Street between Peoria and Utica Avenues commemorates the site of that original post office. But George Perryman's grave—beneath a large heart-shaped tombstone—is easy to find in the family cemetery. He was laid to rest in 1899, one of dozens buried beneath the sod there. Mostly, those buried were Perrymans or settlers from one of the other pioneer families. Some were Civil War soldiers wrapped in blankets, Creek chiefs and warriors, infants who never

◆

Right: *The* Delta Queen, *shown at the Port of Catoosa, is a national historic landmark.*

saw their first birthday, and others who died far too young. Many of the graves are unmarked.

Visitors need to step inside the iron fence and walk among the graves of the Perryman family—George and his wife, Rachel, are at peace near Kizzie, Mose, Pleasant, John, Andrew, Gracie, Abner, Theodore, and all the others. Lydia Beaver, wife of Milton, is there. So are Emma Drew, William Shirk, Mary Marshall and Pete Grayson, Hattie Dunbar, Amos Beaver, and little Delilah— the daughter of China Partridge— eleven years old forever in her grave marked by a stone lamb that somehow has become headless.

Just a short distance from the cemetery, in the midst of the Perrymans' old stomping grounds, is a stylish residential neighborhood and shopping district called Brookside. Among the gas stations, video stores, smart boutiques, galleries, antique shops, and cafes that

Above: *Rick Bilby cooks hamburgers on the grill his great-grandfather Oscar Weber Bilby created in 1891. The grill is thought to be the first used to cook hamburgers in the United States.*
Right: *Cain's Ballroom, in Tulsa's Brady Arts District, is where Bob Wills and his Texas Playboys pioneered the distinctive sound of western swing.*

like to put an accent on the *e* is a rather unpretentious establishment where any number of Perryman ranch hands and old Indian Territory wranglers would have felt right at home. Tulsa visitors, grown hungry after touring venerable trees and graveyards, may wish to follow suit.

At Weber's Superior Root Beer Stand, the offspring of Oscar Weber Bilby quietly explain how a Bilby ancestor invented that all-American culinary icon—the hamburger. Although plenty of other cities and towns around the nation boast that they deserve all the credit for putting that very first patty of cooked beef on a bun, the Bilbys of Tulsa remain confident that Grandpa Oscar beat everyone else to the grill.

They point out that Oscar and his faithful wife, Fanny, moved to Indian Territory from Missouri in the 1880s. The couple ferried the Arkansas River in a covered wagon and settled near the

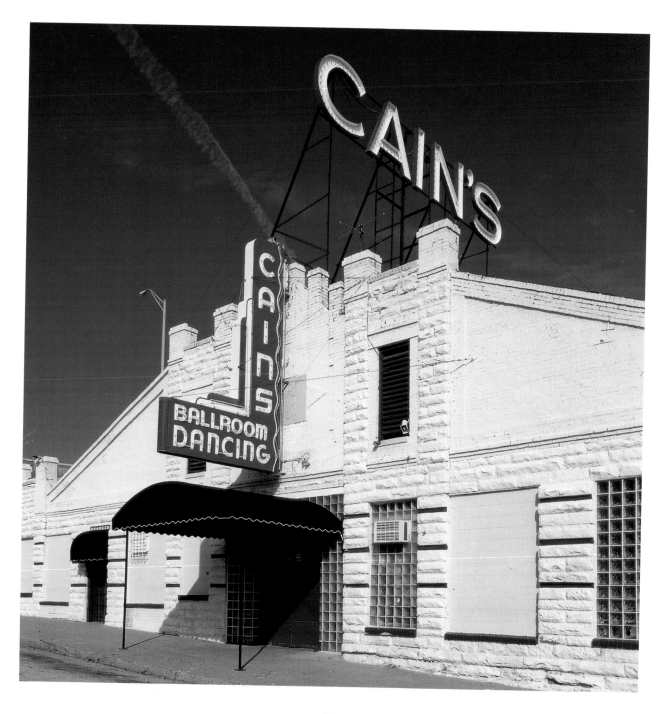

community of Bowden, a few miles north of Sapulpa, erecting a home on 640 acres of farmland purchased for only thirty cents an acre. Oscar and Fanny raised a family, tended an ample garden, and ran a few cattle and hogs. And on that homestead, the Bilbys also made history.

In June 1891, Bilby fashioned a grill from a large piece of scrap iron he had acquired. On the Fourth of July, he built a hickory fire beneath that grill. When the coals were glowing white-hot, he tossed some hand-ground Angus meat on the grill. When the beef was cooked and sizzling, he slid the patties onto some of Fanny's homemade yeast buns—the best buns in the world, made from her own secret recipe.

The Bilbys served those beef sandwiches to neighbors and friends under a grove of pecan trees, along with buckets of fresh ice cream and their hand-mixed root beer that had been aged for months in birch-bark barrels in the cellar. Folks could not believe how good it all tasted. They could not get enough, so the Bilbys hosted another big feed. They did that every Fourth of July, and sometimes as many as 125 people showed up.

Simple mathematics supports the Bilby family's contention that if Oscar served cooked beef patties on Grandma Fanny's fresh-baked buns in 1891, then the Bilby family eclipsed by many years all other contenders who swore that they had unveiled the first hamburger.

Inside the small root-beer stand that has become a Tulsa landmark, that treasured grill still is being used. To ensure that the quality of their hamburgers never

The Greenwood
area, once known as
"the Black Wall
Street of America,"
thrived on revenue
earned by black
workers who
couldn't spend their
money in white
Tulsa. A race riot
leveled the area and
killed many black
residents in 1921.
By the 1940s,
Greenwood was
once again a
prosperous
African-American
cultural district.
In June 1996,
the city of Tulsa
commemorated the
seventy-fifth
anniversary
of the riot.

would waver, in 1933, the Bilbys installed Oscar's old thirty-six-inch by twenty-four-inch grill and converted it to natural gas. For decades, they have continued to fry hamburgers from morning to night, turning out as many as four hundred prizewinning burgers each day.

Right: The 345-foot Philtower, built in 1927, was then the tallest building in Oklahoma. Waite Phillips, financier and philanthropist, donated the office building to the Boy Scouts to endow a Scout ranch in New Mexico.

"This ol' grill has cooked so many burgers that the grease has soaked all the way through," explained Harold Bilby, Oscar and Fanny's proud grandson. "When you come here and drink a frosted mug of root beer and eat one of our old-fashioned burgers, you're tasting history—pure history."

While sitting on a stool and ingesting a hot slice of history on a bun, visitors should remember other aspects of Tulsa. They need to consider Tulsa beyond its beginnings as a Creek Indian settlement and then as a cow town on the Arkansas River, when outlaws stood on Standpipe Hill and used spyglasses to see if any lawmen's ponies were hitched up in front of ramshackle general stores and boardinghouses operated by Indians and whites.

Visitors who truly want to understand the city are obliged to witness all of Tulsa's incarnations. They need to call up the ghosts—famous and infamous. They need to walk the streets, tour the neighborhoods, and talk to the people. They need to experience the city as it has evolved today, but they also must caress and embrace the past. To accomplish all of this means going to parts of town where many Tulsans—out of ignorance, fear, or apathy—never have ventured.

Any tour has to include the important parts of the city that often are overlooked, such as the patchwork of communities and neighborhoods on the west side of the Arkansas, and the entire northern portion of Tulsa. Most folks who live in the tedious suburban housing developments in Tulsa's far southeast, where mature trees are scarce and generic shopping malls and franchise restaurants are the preferred way of life, seldom spend any time in what is generally called West Tulsa. Mostly God-fearing middle-class whites, they no more would go there than they would venture into "the north side," where the majority of Tulsa's black citizens reside. As for West Tulsa, a large number of the city's other residents think of "that part of town" only as a location for blue-collar workers, smelly refineries, and low-income housing. For many Tulsans, the west side of town is still where to go if someone is looking for trouble.

Some of the tales are true. For years, the west bank of the Arkansas was black-eyed and split-lipped—as raw as Oklahoma crude. The area earned a reputation for being bare-knuckled and always thirsty, particularly after a successful football game at Daniel Webster High School. Built during the depression through the WPA, the school was named for the statesman who mythically contended that he had wrestled with the devil and won.

But for thousands of Tulsans who proudly claim the west side as home, there is a different story to be told. As west siders themselves are quick to point out, living west of the river does not mean you are simply a resident

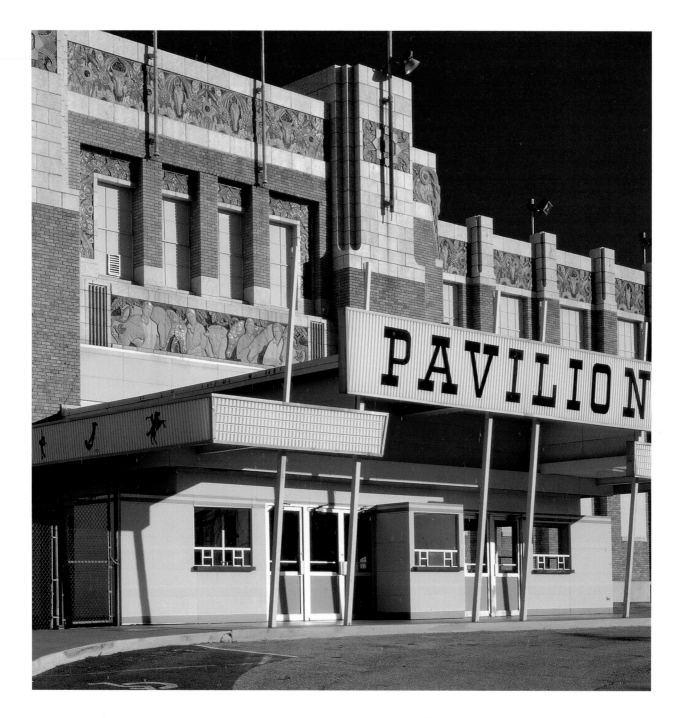

of Tulsa. The west side includes the communities of Red Fork, Carbondale, Oakhurst, South Haven, Berryhill, and Garden City—the chosen habitats for generations of hardworking families who would not dream of living anywhere else. As one feature writer once put it, "Thanks mostly to the natural river boundary, the west side, more than any other part of Tulsa, is a collection of cohesive communities with long-established neighborhoods."

There can be no argument that the two key factors which shaped the development of southwest Tulsa were geography and industry. Situated on the Arkansas in an eternal standoff with Tulsa proper, as most proper Tulsans would put it, the communities making up the west side were molded by their location and the industry that dominates the area.

The west side always has kept the entire city honest. Without the events which transpired on that side of the river, Tulsa would be just another podunk town that people pass through on their way to someplace else.

It happened in Red Fork, one of the dominant communities on the west side, which by the 1880s had become a cattle-shipping point on the Frisco railroad about the same time as Tulsa did. Then a litany of problems, including the lawlessness of settlers, inadequate water, and railroad disputes, took a heavy toll. When the railroad terminal was moved fifteen miles southwest to the town of Sapulpa, Tulsa appeared to be doomed.

All that changed —almost overnight— thanks to Red Fork. Oil was discovered there on June 25, 1901, and the boom was on. Nothing was ever the same.

"A GUYSER [sic] OF OIL SPROUTS AT RED FORK," screamed the headline in the June 28, 1901, edition of the *Tulsa Democrat*. The story told of the stream of

Left: The Tulsa Fairground Pavilion, built in 1932, still showcases many events.
Below: The Creek Council Oak overlooks the Arkansas River at the site where the Lochapoka Creeks held council in 1836 after their removal from Alabama to Indian Territory.

dark green oil gushing from the Sue Bland No. 1, the first oil well in Tulsa County. It was named for the Creek wife of Dr. John C. Bland who, along with John Wick, Jesse Heydrick, and Dr. Fred S. Clinton, financed the venture. "Every train is bringing men of means who want to get a foothold, and every man is at a tension of excitement," the newspaper went on to report of the discovery well that triggered so much prosperity.

In truth, the well was only six hundred feet deep and ended up yielding about ten barrels of crude a day—yet it brought in a whole new crop of citizens and talent from back east, all of them eagerly searching the territory for new drilling sites. With the advent of fresh oil discoveries, Tulsa business leaders built their toll bridge across the Arkansas and promoted their city as a desirable place to live. Tulsa thrived, and began to shake free of its image as an unkempt, tough frontier settlement. One early resident candidly explained, "We had to dodge roaming hogs, goats, and cows when crossing [streets], and sometimes wild animals would venture into the middle of town."

Then in 1905, Tulsa and the entire region got an even bigger boost when Robert Galbreath and Frank Chesley completed the Ida Glenn No. 1, their big discovery well at Glenn Pool, fifteen miles south of Tulsa. It was one of the largest fields of its time. Some of the subsequent Glenn Pool wells flowed twenty-five hundred barrels of high-grade crude a day.

Oil made Tulsa. The city's population swelled as Tulsans built hotels, schools, and even an opera house.

Right: A gargoyle near the entrance of Tulsa's Philtower holds a tiny replica of the building.

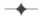

Promoters championed Tulsa as the headquarters for oil captains to conduct their financial business and establish their homes. By 1912, the city was beginning to be known far and wide as "the Oil Capital of the World."

Although such important places as Red Fork largely were forgotten as Tulsa grew in other directions, the folks on the west bank of the Arkansas always have known how much they contributed to the city's success.

West siders still roll up their sleeves every day of the week and go to work. And in the evenings, the working-class beer joints quench the thirsts of refinery workers, truckers, and others who can take any visitor who shows a trace of interest to the Sue Bland No. 1. So can the men and women eating supper at Ollie's Station, a popular spot on Southwest Boulevard, the alias which Route 66 uses through that part of town.

The historic Sue Bland site is only a short way from the restaurant and bars of "Beautiful Downtown Red Fork." A small sign in a field marks the place where Tulsa's first well came in, triggering an epidemic of oil fever that raged for a long, long time.

Another token of West Tulsa pride and spirit can be found not far from Eugene Field School, an old red-brick building named for the children's poet. In a nearby churchyard sits a miniature oil derrick with a cross mounted on top. The plaque at the base says, "Dedicated to all oil men, past and present." It is a fitting tribute, as unassuming and straightforward as the people who placed it there.

Other memorials from the cycles of time—tangible testimonials from the various renderings of Tulsa—await visitors throughout the city.

One treasure trove is the Brady Arts District, an eclectic blend of warehouses, bars, restaurants, photography and art galleries, and studios scattered over a large area just across the railroad tracks from the latest version of downtown Tulsa. The district was named for pioneer Tulsa builder and booster Tate Brady, whose name also graces a street and the nearby Brady Heights residential neighborhood.

The district with Tate Brady's name is also the location of the historic Brady Theater, formerly called Convention Hall, then Municipal Theater, but still fondly known by most Tulsans as "the Old Lady of Brady." According to local legend, even though the city already had an opera house, the early wildcatters and oil barons

who came to Tulsa from back east wanted a larger venue where their families could absorb culture. The theater was erected after citizens braved the frigid weather of January 21, 1913, and voted in favor of the bond issue for the building's construction. The old *Tulsa Democrat* suggested to its readers that Convention Hall would be an ideal addition to "this metropolis of the mid-continent, this city perfect in all ways. . . ."

But the newspaper was wrong. Folks soon found out that the building was not well suited for conventions, but was far better for entertainment and cultural events, as the oil barons had thought. The building was not perfect in all ways, and sadly, neither was Tulsa.

The Ku Klux Klan had begun to become active in Tulsa in 1917, although it had been preceded by the so-called Knights of Liberty— black-robed hooligans who took seventeen dues-paying

Below: Cypress trees line the shore of Greenleaf Lake, one of Oklahoma's most tranquil places.
Right: The Frederick Drummond Home, in Hominy, is a Victorian-style house built in 1905 by a Scotsman who was a merchant and trader. His sons formed Drummond Cattle Company, and descendants still ranch in the area.

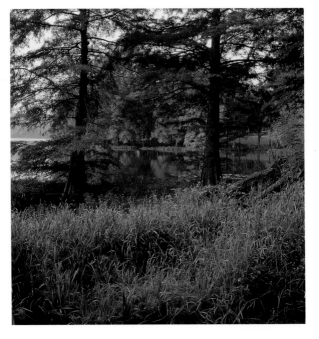

members of the International Workers of the World to the edge of the city to be beaten, tarred, and feathered.

Klan members carried out their own acts of terrorism in Tulsa during the late teens and early 1920s. They focused their hatred on members of trade unions, blacks, Jews, Asians, Catholics, and anyone else who did not fit their Anglo-Saxon, Protestant, red-blooded American mold.

On April 1, 1922—appropriately enough, the day set aside for fools—the Klan came to Convention Hall. As many as 1,741 Klansmen, each swathed from head to toe in white, gathered at the building. In silent parade, marching three abreast, they proceeded south on Main Street and then through the downtown avenues, where at least fifteen thousand Tulsans lined the route. The first of the marchers arrived back at Convention Hall a full half hour before the last of their cohorts had left.

The Klansmen already knew the way to the Old Lady of Brady. Many of them had been there just the year before their big parade. They had appeared at the

Left: The Spanish-style home of oilman H. V. Foster, with its commanding tower, contains thirty-two rooms and fourteen bathrooms. Today it houses the library and administrative offices of Bartlesville Wesleyan College.
Above: The American Bison, *by sculptor Stephen Le Blanc, is in popular River Parks, along the Arkansas River within walking distance of downtown Tulsa.*

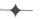

building during those horrible days and nights of madness in late May and early June of 1921, when the most hideous episode in Tulsa's history unfolded. The tragedy was provoked by the incarceration of a black youth who allegedly had molested a white female elevator operator.

The madness that followed—commonly referred to as the "Tulsa race riot"—was the single most devastating incident of racial violence in the twentieth century. Roving gangs of armed whites—driven by anger, hatred, and ignorance—randomly looted, plundered, torched, and murdered their fellow black citizens. It probably never will be known exactly how many corpses were dragged off to ravines in the Osage Hills and disposed of in mass burial pits.

It was during that period of sheer terror and unspeakable violence that the Old Lady of Brady became a prison. National Guardsmen and "special deputies" rounded up entire black families and brought them to internment centers at McNulty Park, the fairgrounds, and Convention Hall. Soon the auditorium

The Santa Fe Depot is now home to the Bartlesville Chamber of Commerce, with Phillips Petroleum offices in the background.

overflowed with men, women, and children torn from their homes. Finally, it could hold no more.

Thankfully, the black community, the city of Tulsa, and the theater survived. The KKK and other hatemongers no longer march through the neighborhood. The Old Lady remains, not as a warehouse for trampled people, but as a place for musicians, poets, clowns, magicians, and storytellers. A chorus of sweet voices and high notes ricochets off the walls.

It is said that Enrico Caruso's ghost lingers in this building. That just may be. Prior to a 1920 performance at the theater, the famed virtuoso took an open-air ride through the damp northeastern Oklahoma countryside and contracted the pleurisy that led to his death a year later. And if the celebrated tenor continues to play the Old Lady of Brady, then possibly other phantoms and spirits also are there. Perhaps they frequent the hidden cobwebs, the well-worn lobby, and the dressing rooms. Perchance they congregate on a stage that has showcased George M. Cohan, Arturo Toscanini, Will Rogers, Helen Hayes, Katharine Hepburn, Pete Fountain, Beverly Sills, Carol Channing, Elvis Presley, and Maya Angelou.

The music, poetry, dance, and laughter have cast a spell on the Brady and helped to purge some of the misery and suffering that Tulsa had to endure. The Old Lady of Brady lives on, just like its neighbor only a short distance away—Cain's Ballroom, celebrated around the world as the birthplace of an American music phenomenon known as western swing.

Originally intended to serve as an automobile dealership when Tate Brady built it in 1924, the building was transformed into a dance hall dubbed the Louvre Ballroom. A short time later, it became known as Cain's Dancing Academy, where Professor Madison "Daddy" Cain taught Tulsans the finer points of ballroom dancing.

But Cain's Ballroom truly earned a place in Tulsa history during the midst of the Great Depression. The big wooden dance floor, mounted on truck springs, was crowded with couples swaying to the western-swing music originated by Bob Wills and the Texas Playboys. The distinctive musician from Turkey, Texas, and his brothers Johnnie Lee and Luther entertained at Cain's for many years. So did many other musical legends—Hank Williams, Ernest Tubb, Tennessee Ernie Ford, Gene Autry, Patsy Cline, Hank Thompson, and Leon McAuliffe.

Thankfully, Cain's Ballroom—described as the "Carnegie Hall of Country-Western Music"—is still working its magic for Tulsa. Sometimes when the moon is full and glowing white and worthy of a howl, visitors leaving a dance at Cain's might be able to hear the ghostly voice of Bob Wills riding the summer breeze.

Shangri-La Resort, on an island in Grand Lake o' the Cherokees, boasts accommodations for four hundred, a golf course, full-service marina, restaurants, and a huge conference center.

"Would I like to go to Tulsa?
You bet your boots I would,
Let me off at Archer,
I'll walk down to Greenwood,
Take me back to Tulsa."

Beyond the classic Bob Wills tune, Tulsans remember the old commercial area around Greenwood and Archer for other reasons. The once prosperous neighborhood became a magnet for black entrepreneurs and earned the nickname "the Black Wall Street of America." Much of the Greenwood area was shattered and destroyed during Tulsa's nightmare of June 1, 1921.

Eventually, after decades in limbo, the Greenwood neighborhood was revitalized. Old businesses returned, and some new merchants moved there. Besides the nearby Brady Arts District, the attractive urban campus of Rogers University has joined the neighborhood scene. Greenwood—the place that for so long attracted some of the greatest players in the history of jazz and blues—once again reverberates with music festivals and concerts.

Near Greenwood Cultural Center stands a memorial to the self-sufficiency and spirit of Tulsa's black community. Chiseled in the smooth stone is a brief description of the long-ago madness when, within twenty-four hours, as many as three hundred black citizens died and thousands of homes and businesses in a thirty-six-square-block area were destroyed. The monument lists some of the churches, theaters, drugstores, laundries, shoemakers, tailors, cafes, hotels, dentists, doctors, newspapers, factories, and schools that vanished.

It is crucial that the city never forgets that time of horror. Yet there is comfort that at last the thick gray pall that hung over north Tulsa has departed. Standing at the memorial in Greenwood, visitors can see what Tulsa has become. Reflected in the monument's shiny surface is the mix of old and new buildings on the skyline.

Like many other American cities, downtown Tulsa looks like a prizefighter's mouth, with many missing teeth. Some of Tulsa's finest architectural treasures—true art deco gems—have been lost forever, turned into asphalt parking lots. But fortunately, some of the outstanding buildings—including several designed by Bruce Goff—have survived the wrecking ball and remain as tributes to past eras, as do the city's fine museums.

The Gershon and Rebecca Fenster Museum of Jewish Art, one of Tulsa's best-kept secrets, houses one of the largest collections of ceremonial and aesthetic Judaica in the nation. Both Gilcrease Museum, with its unsurpassed art and artifacts from the American West, and Philbrook Museum of Art, with its peerless but unsung Native American collection, are the result of Tulsa's rich oil legacy.

After touring the palaces of culture, historic sites, and Tulsa's many hidden treasures, travelers may venture forth and embrace all that Oklahoma's northeast has to offer. Those extra special places abound in Bartlesville, Claremore, Tahlequah, Muskogee, and throughout the region.

Travelers might spend a bit of time at the graves of Will Rogers, "Pretty Boy" Floyd, Belle Starr, and the talking horse named Mr. Ed. They need to see the landlocked submarine near Muskogee and the Tom Mix Museum in Dewey, and then experience the nearby

Frank Lloyd Wright designed the nineteen-story Price Tower, which was completed in 1956 in downtown Bartlesville.

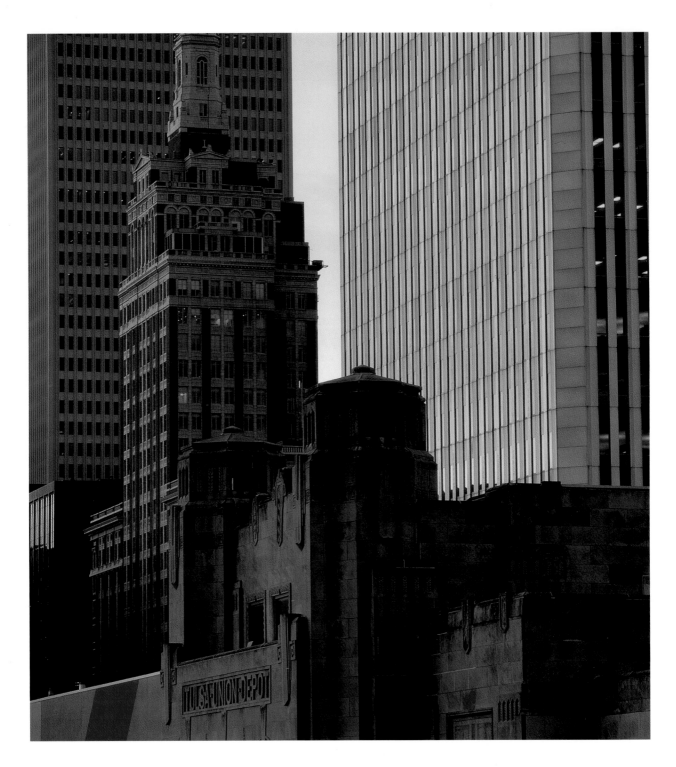

restored slice of frontier life with the lyrical name of Prairie Song. There are the colorful murals of Hominy, the blue whale at Catoosa, the concrete totem poles near Foyil, the restored Coleman Theater in Miami, Frank Lloyd Wright's Price Tower in Bartlesville, and so much more.

Maybe the best place to conclude the journey is where so many have started their trek—in the timeless land of the Osage.

Some folks were fortunate to have been present at the Tallgrass Prairie Preserve in 1993 when bison were reintroduced to those Osage prairie lands. On an early autumn day, the seed herd was released. Songbirds called and wind rippled across the bluestem and Indian grasses as three hundred "monarchs of the plains" lum-

bered out of the fog to reclaim their place in the cycle of life.

The last two of the herd—a cautious calf and a shaggy old bull—passed in review. Running side by side, the pair represented the past and present as they disappeared with the others into the largest expanse of tallgrass prairie remaining on the continent.

After the bison herd was long gone and out of sight, some of the Osage men and women who had come to watch the release stood transfixed by what they had witnessed. They had heard about the bison from soothsayers and from old ones who had taken part in some of the final hunts so very long ago. They recalled those stories, and they smiled. Their children and grandchildren, on holiday from school so they could witness history, played in the thick grass.

It was a moment to treasure—a flash of time in a land that time has forgotten. Life had come full circle. ◆

Left: The 1931 Tulsa Union Depot, overshadowed by taller buildings, is an impressive example of art deco architecture.

Acknowledgments

The process of writing this book was enhanced greatly by the input and influence of my wife and best friend, Suzanne Fitzgerald Wallis, and of Hazel Rowena Mills, the most diligent copy editor and guardian of history I know. My everlasting thanks and gratitude to both of you for all your help, support, and wisdom.

Just knowing that I could rely on the staff of The Wallis Group, the absolute best public relations–advertising agency in Oklahoma, allowed me to sleep well at night. Many thanks to Melani Hamilton, Stacy Ryle, Linda Adams, Janet Gaddis, and all the rest of the crew. A special tribute must go to Lynne Henson, a remarkable woman who helped lighten my load and contributed so much to this book's development.

A special salute to the editorial team and the entire staff at Graphic Arts Center Publishing, especially Doug Pfeiffer, Ellen Wheat, Jean Andrews, and Mary Ransome. Heartfelt thanks go to each one of you.

Michael Carlisle, my talented agent and vice president of the William Morris Agency, deserves high praise for his invaluable assistance. Much appreciated, Michael.

Finally, my thanks to Allen "Storm" Strider, Christopher and Linda Lewis, Dr. Lydia Lloyd Wyckoff, and Beatrice and Molly, my faithful feline muses.

— MICHAEL WALLIS

First of all, I wish to thank Governor George Nigh who gave us the idea for this book. A partial list of the many others who contributed in their own special ways follows: Jeff Briley, who was an excellent traveling and camping companion on many of my trips and who has almost convinced me to take up fly fishing; Nancy Phillips of the Tulsa Convention and Visitors Bureau, whose suggestions, information, and assistance were absolutely invaluable to this project; and Lanny Landrum, park manager at the new Natural Falls State Park, whose enthusiasm was contagious.

Space and time will not allow me to list all of those great people who helped me along the way in producing *Oklahoma Crossroads*. To all of you—and you know who you are—many thanks. Some of those who opened doors for me and made this book possible are pilots Mary Kelly of Cookson Airport and Gary Forshee of Grove Aviation; Julie Kiddie, marketing manager of the Cherokee Nation of Oklahoma; Joseph H. Carter of the Will Rogers

Memorial in Claremore; Dick Miller of Frank Phillips' Woolaroc near Bartlesville; Randy Ledford, site manager of the Pawnee Bill Museum, Pawnee; and the public relations persons of two elegant art galleries, Gilcrease and Philbrook, of Tulsa.

I especially want to thank Michael Wallis and his lovely wife, Suzanne Fitzgerald Wallis, whose warmth, enthusiasm, and superb knowledge of the subject made my contribution much easier. To share in the creation of this book with such a gifted writer as Michael Wallis has indeed been a privilege and an honor.

— DAVID FITZGERALD

Technical Information

All images were made on Hasselblad ELX and Hasselblad 903 SWC cameras. Lenses include the 40mm CF, 50mm CF, 80mm CF, 150mm CF, 250mm CF, 350mm CF, and 500mm CF.

With the exception of pages 24 and 68, where Kodak Ektachrome Lumiere 100X 120 was used, all other images were produced on Kodak Ektachrome E100 SW in both 120 and 220 sizes.

Polaroid type 664 was used to check exposure and composition.

MICHAEL WALLIS, a native of Missouri, has lived and worked throughout the West. His writing has been published in hundreds of magazines and newspapers, and he has authored eight books. He was a nominee for the National Book Award and three of his books have been nominated for the Pulitzer Prize. Michael has received numerous honors, including the first Steinbeck Award and the Lynn Riggs Award. He was the first inductee into the Oklahoma Route 66 Hall of Fame and also was inducted into the Oklahoma Professional Writers Hall of Fame. He and his wife, Suzanne Fitzgerald Wallis, have lived in Oklahoma since 1982.

DAVID FITZGERALD'S photographs have appeared in commercial advertisements for national and international clients, as well as in six books, all published by Graphic Arts Center Publishing Company. He is the official photographer of Aerospace America and a contributing editor of *Oklahoma Today* magazine. His work is included in permanent collections of the State Arts Collection housed at the Kirkpatrick Omniplex; the University of Central Oklahoma's Donna Nigh Gallery; and the University of Oklahoma's Museum of Art. In 1996 David received the Outstanding Tourism Contributor award from the Oklahoma Department of Tourism and Recreation. ✦